Capturing the Moment in Oils

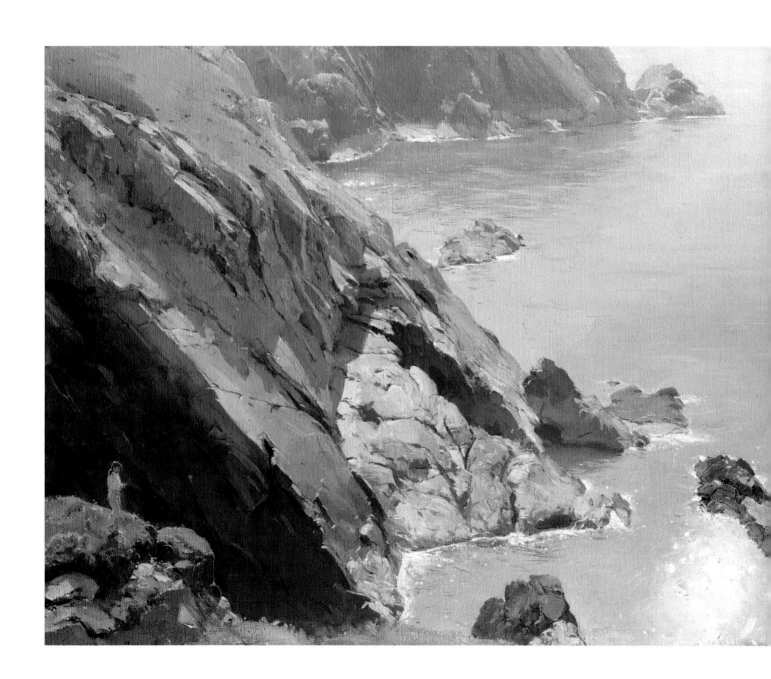

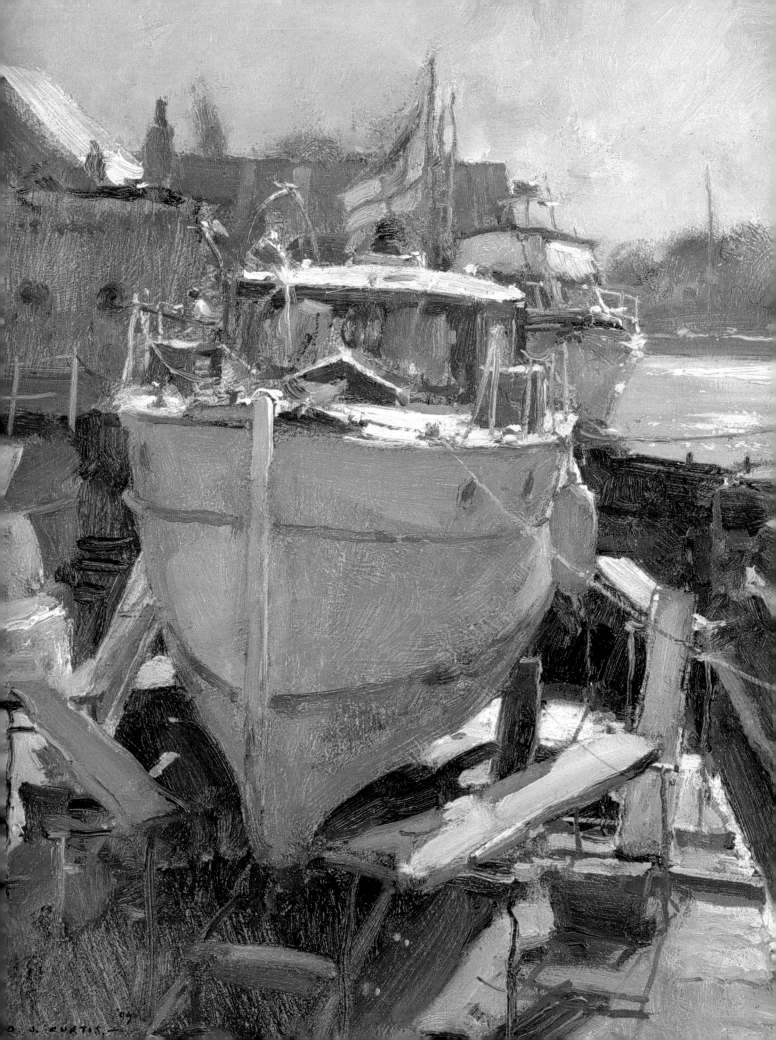

Capturing the Moment in Oils

David Curtis
with Robin Capon

BATSFORD

To my family, friends and painting companions
For Susan and Matthew

Acknowledgements

My special thanks to Robin Capon for his work on the text. He has shown a real empathy and understanding in conveying my thoughts and ideas, and it has been a genuine pleasure to work with him, both on this book and my previous one, *Light and Mood in Watercolour*.

www.djcurtis.co.uk
david@djcurtis.co.uk
David Curtis is represented by Richard Hagen, Stable Lodge, Broadway, Worcestershire WR12 7DP.
Tel: 01386 853624; www.richardhagen.com

First published in the United Kingdom in 2006 by
Batsford
151 Freston Road
London W10 6TH

An imprint of Anova Books Company Ltd

ISBN-13 9780713490077
ISBN-10 0 7134 9007 1

A CIP catalogue record for this book is available from the British Library.

10 9 8 7 6 5 4 3 2 1

Reproduction by Classicscan, Singapore
Printed by Craft Print International Ltd, Singapore

This book can be ordered direct from the publisher at the website:
www.anovabooks.com, or try your local bookshop

Distributed in the United States and Canada by Sterling Publishing Co.,
387 Park Avenue South, New York, NY 10016, USA

[Half-title page] **Pembrokeshire Sea Cliffs, Port St Justinian**
Oil on canvas, 61 x 76 cm (24 x 30 in)

[Title page] **The Dry Dock, Thorne, Yorkshire**
Oil on board, 30.5 x 25.5 cm (12 x 10 in)

Contents

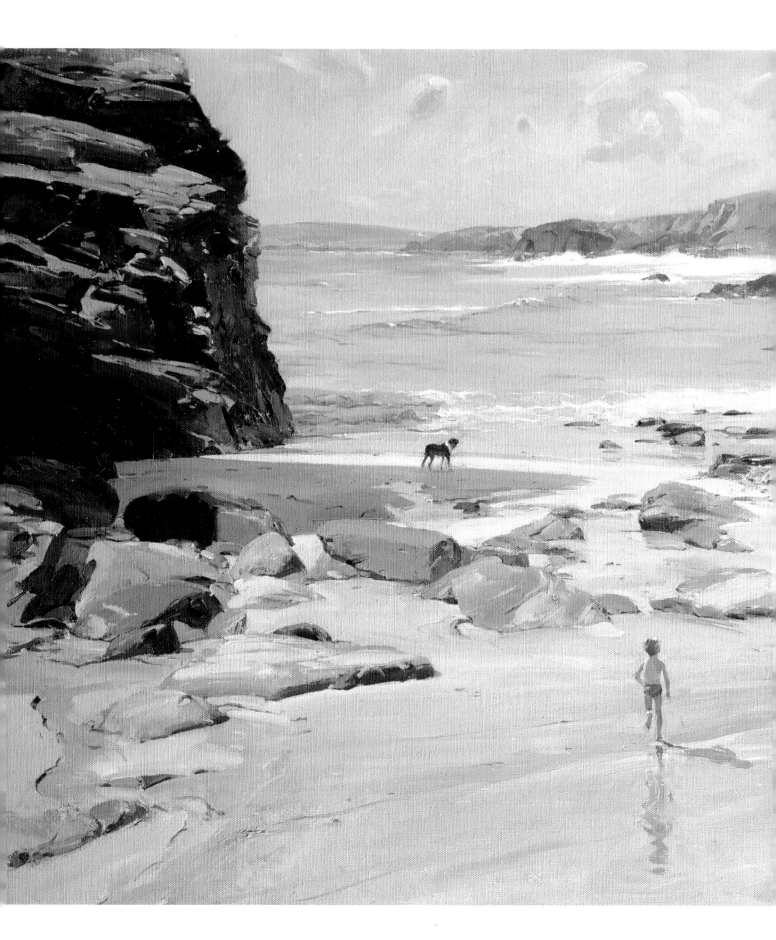

Introduction

Oil paint has always been the medium in which I have felt most confident. From the very first time I used it, in my early teens, I instinctively knew that it was the most suitable medium for my kind of painting – which even in those early, formative years was principally expressive, *plein-air* work (that is, painting outdoors). Naturally, to begin with, my colours were sometimes harsh and my attempts at handling paint rather crude and 'lumpy', but I instantly liked the feel of oil paint and the way that it could be moved about to shape forms and effects on a canvas or board. Without doubt that Christmas gift of an oil-painting set, when I was about 12 years old, proved to be an extremely significant present!

Above: David Curtis in his studio

Left: *A Pembroke Beach*
Oil on canvas, 61 x 76 cm (24 x 30 in)
'I paint beach scenes throughout the year; they are one of my favourite types of subject matter.

I remember quite clearly the first painting I did outside. It was a simple farmyard scene with a ginger cat in the foreground, and it still hangs in my mother's bedroom. Guided by some very experienced local artists, notably Andy Espin-Hempsall, I soon began to appreciate the strengths of oils – both in terms of colour and technical range – for capturing the essence of a subject speedily and successfully. A quality I started to exploit, and which remains vital to the way I work today, is the fact that oils can be used in a very direct manner. If desired, a painting can be developed in a single session as a 'one-hit' process, with no further modifications.

Since those early days I have continued to explore the potential of oils for expressing the many different subjects and effects that inspire me to paint. I have now been painting for more than forty years, and from my experience I would certainly single out perseverance as one of the most important qualities that artists need. It takes a good deal of time and hard work to acquire the necessary skills and confidence, and even the most accomplished painters accept that there is always something new to learn.

As you will see when you study the text and illustrations in this book, I place great emphasis on observation and composition. Also, I firmly believe that figurative painters need good drawing skills. Exciting subject matter, accomplished technique and a sensitive use of colour are all very important aspects of painting, but the overall impact is invariably weakened if there are faults in the drawing or design.

Additionally I would like to make the point that while I love oil paint, I do not view it as an exclusive medium. I also paint in watercolour, and in the past I have worked in various other media, including pastel and pen-and-ink. There is great value, I think, in having the ability to switch from one medium to another. It gives you a fresh perspective, a different way of looking and understanding, and one medium can inform another. Often in the studio, and occasionally outside, I will start with an oil painting and then move on to work in watercolour, or vice versa. I find this a good way to keep my paintings lively and interesting.

This book covers every aspect of my working methods, from the materials I use to varnishing and framing the finished paintings. In all my work, whether in oils or watercolour, the transient effects of light, weather and mood are the features I am usually concerned with the most. Sometimes I paint in the studio, working from location drawings and similar reference material, but more often I paint on the spot, directly from the subject matter. In my opinion there is no substitute for this approach, and no more rewarding way of painting than to place a brushstroke in direct response to something you have just seen.

I think it is a pity that modern-day painters are less inclined to work outdoors. But if this book encourages more artists to adopt a *plein-air* approach, then I shall be delighted – there is no greater creative experience! Working on site is more rewarding for the artist, and similarly beneficial for the paintings, invariably giving them an inherent integrity and a real sense of connection with a certain place and time.

Brancaster Foreshore, Norfolk Coast
Oil on board, 30.5 x 40.5 cm (12 x 16 in)
I like to work directly from the subject whenever I can, and I greatly enjoy the challenge of atmospheric scenes such as this.

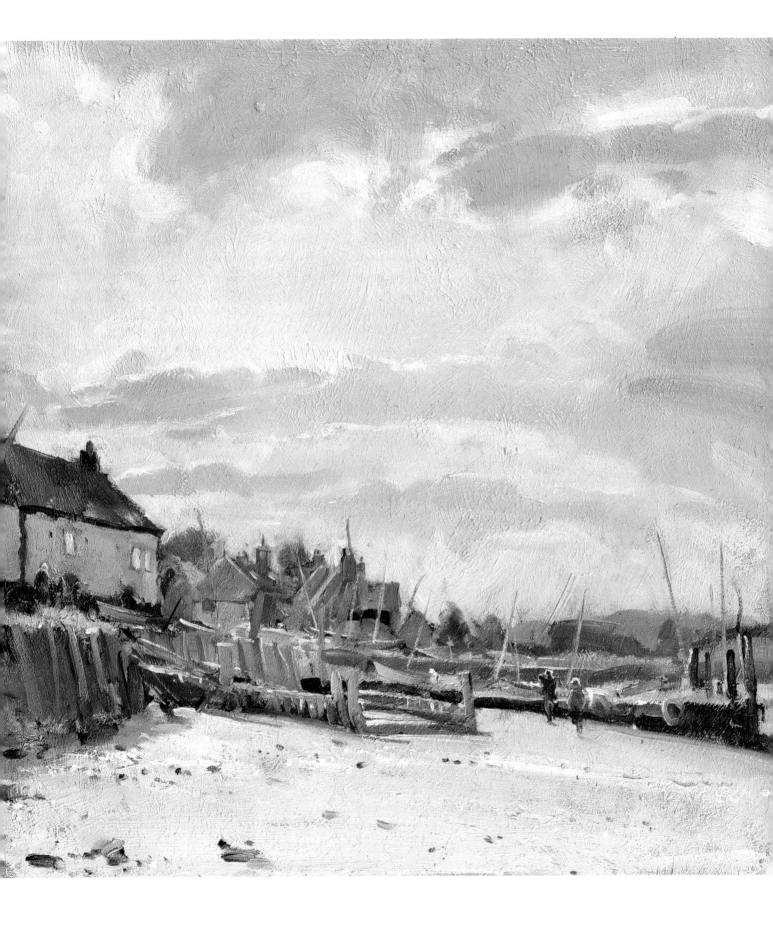

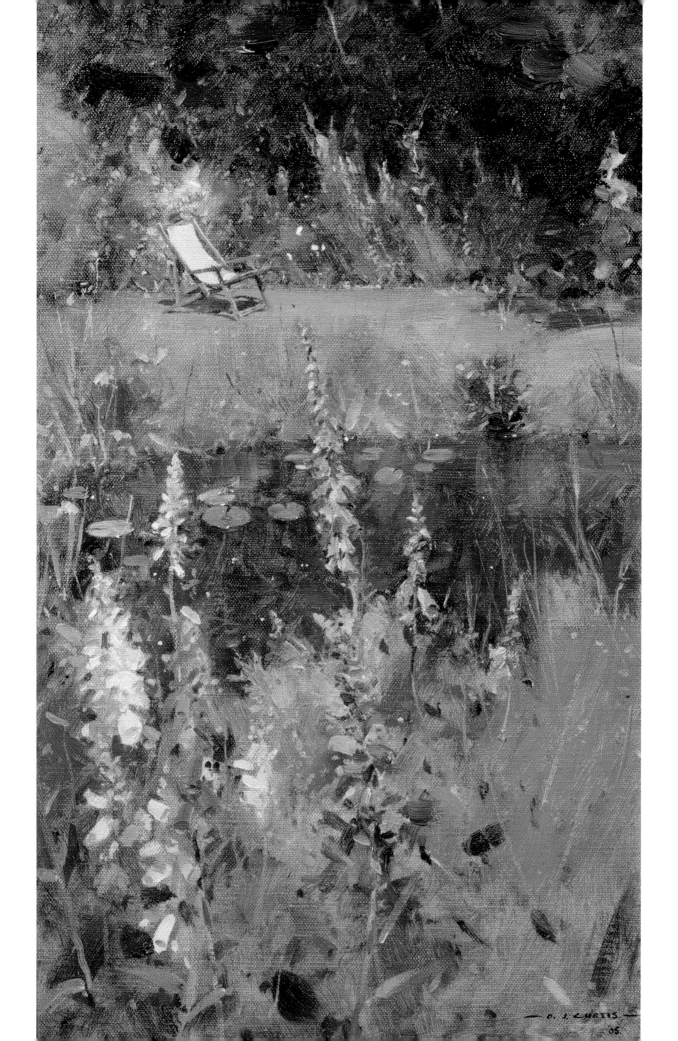

1 Making a start

Each painting medium – be it watercolour, oils, acrylics, tempera or gouache – has its own character, potential and limitations, and naturally it takes time, as well as a good deal of commitment and perseverance, before we can start using the medium with confidence. An interesting aspect of oil painting is its long history, and this is something that can obviously benefit the present-day artist, who can learn from many well-established procedures and techniques. Placing an emphasis on traditional skills is always a good way to begin, I think. Of course the eventual aim is to paint in a style that is distinctly your own, but the best means of achieving that is to first arm yourself with a sound understanding and knowledge of oil paint and oil-painting methods.

I know from my own experience, when I started painting in oils more than forty years ago, that progress depends on a willingness to experiment, and indeed learn from the mistakes that inevitably occur. I went out painting with much older and far more skilful artists, and I soon found that the best way to start in oils was to paint with broad areas of colour and to think in terms of simple, block-like shapes. I was advised not to use the paint too thickly to begin with; to avoid body colour (the addition of white paint in a mix) until the later stages of a painting; to set the dark tones with pure colour, while leaving the extreme whites as areas of unpainted canvas or board; and to work with bold, contrasting strokes.

In this way, I was told, I would be able to control the painting right from the start. It was good advice, and certainly advice that I, in turn, would offer others. The essential things to remember in oil painting are to work from thin to thick paint (what is known as painting 'fat over lean'); to consider the general shapes before any detail; and always to avoid unnecessary detail.

Pond and Garden, Gibdyke House
Oil on canvas, 51 x 30.5 cm (20 x 12 in)

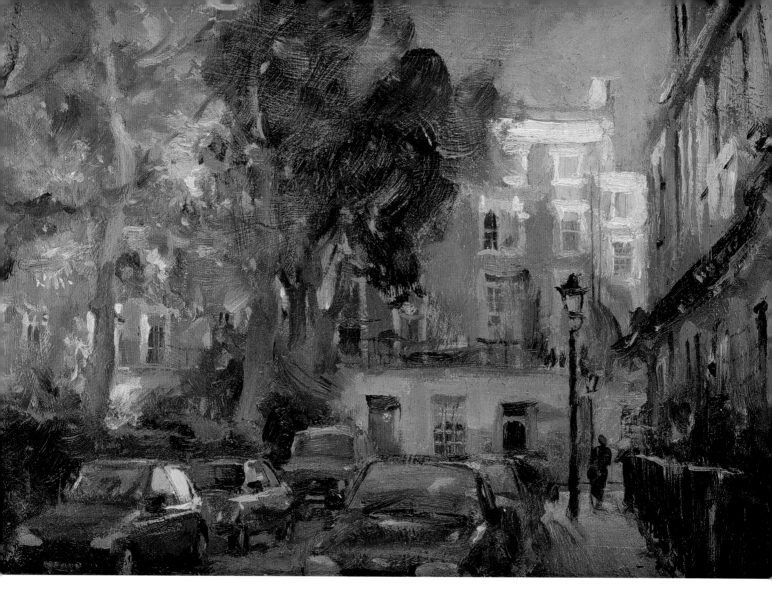

A Versatile Medium

Oil paint has very distinctive paint-handling characteristics, and what makes it so different from other media is the richness and resonance of the colour quality that can be achieved, and the potential for very expressive marks, textures and surface effects. It is not, as many people are inclined to believe, suited only to large studio paintings. As *A Kensington Side Street* (above) shows, oil paint is also an excellent medium for *plein-air* work, especially for capturing the fleeting effects of light, which is something that particularly interests me.

In fact, when painting outside, I would say that I usually capture a light effect better in oils than in watercolour. For me, oil paint is ideally a 'one-hit' medium, by which I mean the colours are applied in a quick, direct way, as more or less finished colours with no subsequent glazing or overworking, as explained in the section on *alla prima* (page 31). I also regard it as the prime all-weather medium. Watercolour is restricted in damp conditions, but with oils there is always the chance of at least setting down the essence of a scene – I have even painted in a snowstorm! I find the plasticity of the medium enables me to tease out the most incredible atmospheric effects, and, as you can see in *Old Fishing Vessels, Peel Harbour, Isle of Man* (right), strong darks really sing out and play their part in a composition painted in oils.

A Kensington Side Street
Oil on board, 18 x 25.5 cm (7 x 10 in)
For me, oil paint is the perfect medium for small *plein-air* paintings that aim to capture a fleeting effect of light and mood.

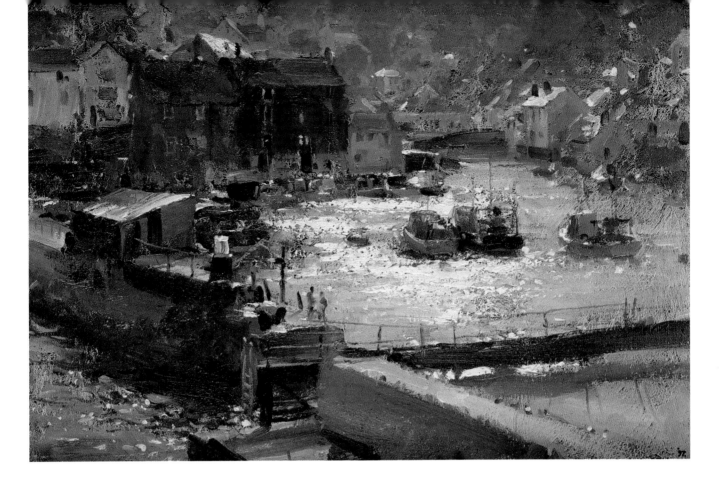

Above: *Afternoon Light, Polperro Harbour, Cornwall*
Oil on board, 25.5 x 35.5 cm (10 x 14 in)
This was a *plein-air* study that I made in preparation for a larger, studio painting.

Left: *Old Fishing Vessels, Peel Harbour, Isle of Man*
Oil on canvas, 51 x 51 cm (20 x 20 in)
Here, for this more complex composition painted in the studio, I worked mainly from photographic reference and sketches.

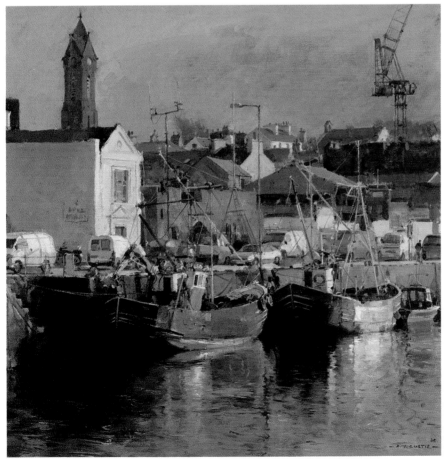

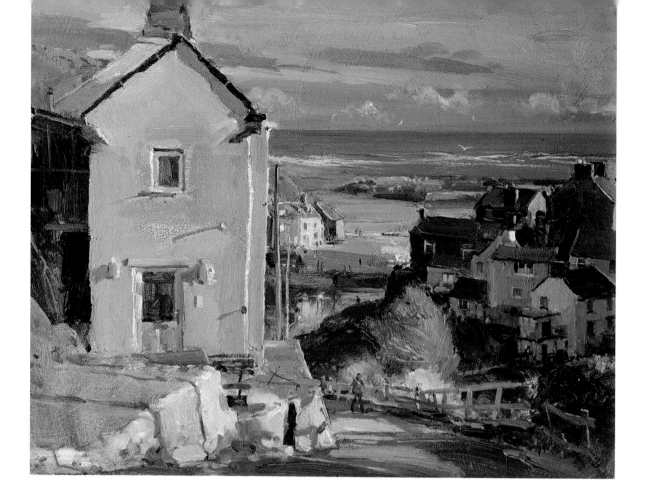

Different Approaches

Many different working methods are possible in oil painting, and so with experience it is possible to select those techniques that are the most appropriate for the subject matter and effects you have in mind. The main techniques are explained on pages 31–39. However, whatever techniques are involved, their success and impact will depend to a large extent on the type of board or canvas surface that is chosen, and the way it is prepared.

When I paint outside I use prepared boards, as described below. But, after assessing the subject matter and the particular qualities that I want to concentrate on, as well as choosing a board of a certain colour, I decide whether I want to start with a wet surface or a dry one. Generally I like to work on a wet surface for subjects in which the dominant atmospheric or lighting effect would be best interpreted by drifting one colour into another. With a dry surface, on the other hand, I have already established an overall mid-tone against which I can place and subsequently develop strong lights and darks, as demonstrated in *Sparkling Light, Staithes Beck* (bottom right).

Sometimes I prepare the board with an initial overall wash of colour the day before I intend to paint on site, and this gives a workable, though not slippery surface over which to create various effects of light and texture. On other occasions I apply the wash as the starting point for the painting and, while it is still wet, use a rag to remove the paint in those areas where I want highlights or extreme lights. Modifying the wet surface with different types of brushwork, or blending other colours into it, are useful techniques for suggesting a sense of distance or expressing the idea of fog, mist or other atmospheric effects. In the studio I may work on canvas, adopting similar methods for the initial ground colour and underpainting.

Above: *View from Cowbar Rise, Staithes*
Oil on board, 25.5 x 30.5 cm (10 x 12 in)
Whenever possible I prefer to work on site, directly from the subject. Outside, the paintings are usually small scale and painted on a prepared board.

Top left: *Canal Basin, Bruges*
Oil on board, 25.5 x 18 cm (10 x 7 in)
I liked the drama of the contrasting tones in this low-light subject, and my aim was to capture the effect as quickly as I could, before anything changed.

Top right: *Calm Waters, Loch Linnhe, Argyll*
Oil on board, 30.5 x 25.5 cm (12 x 10 cm)
I painted this lovely atmospheric scene from a cottage window.

Bottom right: *Sparkling Light, Staithes Beck*
Oil on board, 23 x 30.5 cm (9 x 12 in)
For this study I used a board that was already prepared with a dry, mid-tone ground, which enabled me quickly to place and develop the strong lights and darks.

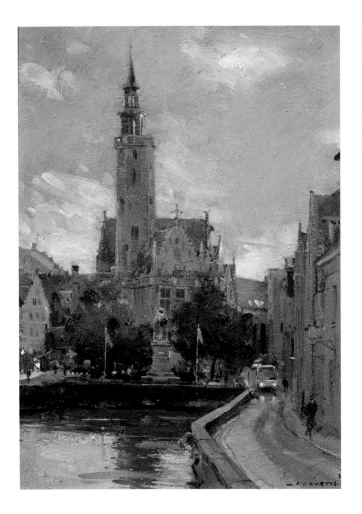

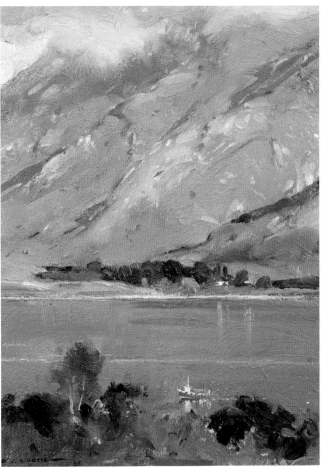

Light over Dark

In the studio, obviously, it is possible to work on a much larger scale, take your time and tackle more complex subjects and ideas. *Paris Boulevard in the Spring* (below) is an example of one of my studio paintings, which in this case was developed from a small pochade-box oil sketch, some photographs, a number of sketchbook studies (mainly of cars and people) and of course my memory of the scene. Another approach I sometimes use is to start a painting outside and finish it later in the studio. It could be that the weather, light or some other factor prevented me finishing the painting on site. *Blakow Hill, Nottinghamshire* (right) was painted in this way.

But whether I work in the studio or outside, I want the painting to have an Impressionist quality, to feel spontaneous and of the moment. At all costs I try to avoid any of the brushstrokes looking laboured. Rather, I want them to appear as though they were made instinctively and freely. This is easier to achieve outside,

Paris Boulevard in the Spring
Oil on canvas, 51 x 66 cm (20 x 26 in)
This studio painting was inspired by a small oil sketch made on the spot. Additionally I used sketchbook drawings as references for the figures and cars.

of course, where there is a greater sense of urgency because of the constraints of time and light. Another difference when working outside is that the approach is essentially *alla prima*, whereas in the studio the painting can be developed in stages and, if necessary, the paint built up in layers.

As I have mentioned, oil paint should be applied 'thick over thin' – that is, thinly to start with, with thicker layers on top. Principally this is because thin paint dries quicker than thick paint. Therefore, if you work the other way round – thin over thick – the underpainting will dry slower than the rest, which most likely will lead to cracking of the paint surface. What is also interesting about oil painting is that usually the dark areas are established first, in the thinnest paint. Essentially the process is one of working lighter colours over darker ones, finishing with the highlights, whites and other pale colours, which are handled as bolder, impasto strokes. This is in direct contrast to the approach used for watercolour painting, which relies on working dark over light.

Blakow Hill, Nottinghamshire
Oil on board, 30.5 x 40.5 cm (12 x 16 in)
Sometimes, as here, it is not possible to complete the painting on site due to weather conditions or any number of other factors. The finishing touches are therefore added later, in the studio.

History and Tradition

Despite the wide choice of painting media available today, oil painting remains a popular technique, especially for figurative work. It was the Flemish artists of the early 15th century who first used oil paint, and thereafter the medium soon attracted attention throughout Europe. While fresco and tempera painting, which were the techniques commonly used at that time, had their own particular aesthetic qualities, they could not rival the level of realism and variety of effects that were now possible with oils.

If you research the history of oil painting you will find numerous great artists whose work will inspire and help you. The Dutch painters, such as Rembrandt and Hobbema; the Barbizon *plein-air* artists, including Corot and Daubigny; Constable; and of course the Impressionists, perhaps especially Sisley, Pissarro, Monet and Cézanne, are just a few of the artists and movements worth considering. As well as looking at art books, visit some of the major galleries if you can and view the actual paintings. Additionally, there are plenty of exciting oil paintings by contemporary artists that can be seen at exhibitions staged by the major societies at the Mall Galleries in London and at other venues.

Above: *On the Hard, Cadgwith Cove*
Oil on board, 30.5 x 40.5 cm (12 x 16 in)
Choice of viewpoint is another factor that can add drama to a painting. Here, I chose a low viewpoint to make the most of the interest and impact in the scene.

Right: *Low Tide, Mevagissey, Cornwall*
Oil on board, 30.5 x 40.5 cm (12 x 16 in)
This was quite an ambitious subject to attempt *plein air*, but fortunately I had time and conditions on my side. Some of the details were added later, in the studio.

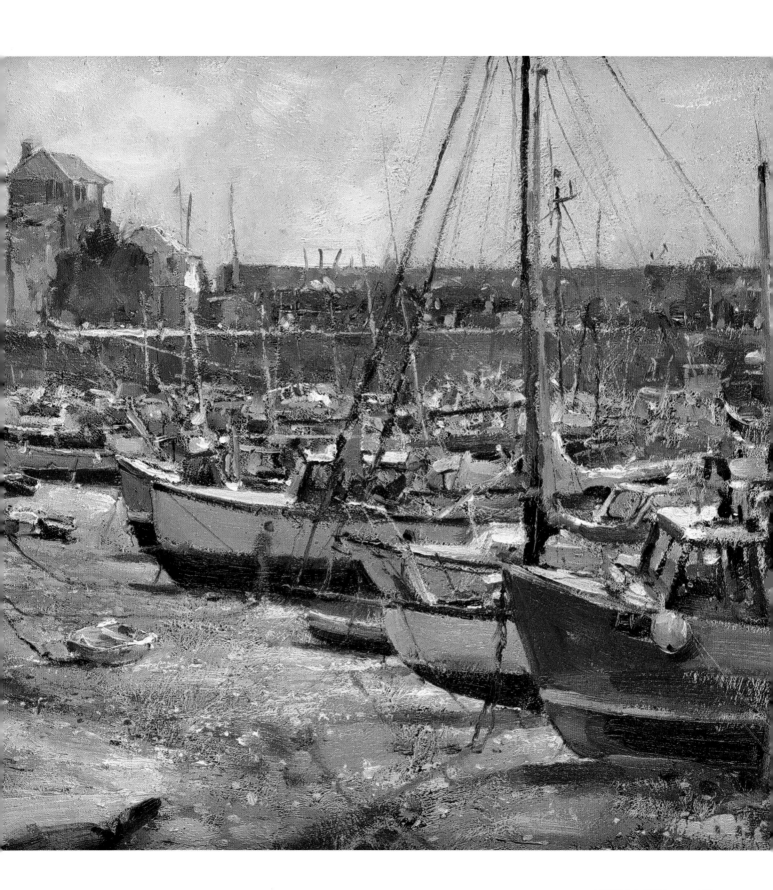

Influences

It can be immensely rewarding to study paintings by artists whose work you admire. However, it is never a good idea, I think, to try to emulate the style of another artist. On the other hand, you may well find small aspects of technique, unusual colour mixes, a particularly striking composition, or similar points that are interesting and worth experimenting with. In this way you may decide to adapt and assimilate something you have noticed in another painting into your own range of working techniques.

I have always loved the work of the Impressionists, painters such as Monet and Pissarro, who were able to capture so convincingly the transient effects of light. Equally, I enjoy the paintings of lesser-known artists, for example Walter Langley, a Newlyn School artist who explored the technique of painting with a square-ended brush to create skilfully drawn, beautifully crisp shapes.

I admire too the garden paintings of Douglas Stannus Gray, with their joyous, Impressionistic touch and wonderful sense of dappled light; the marine and figure subjects painted by Henry Scott Tuke; the impressive, large-scale pictures of horses by Lucy Kemp Welch; and the work of Harold and Laura Knight, who painted at one of my favourite places, Staithes. These are just a few of the artists whose work I have found interesting and inspirational during my career.

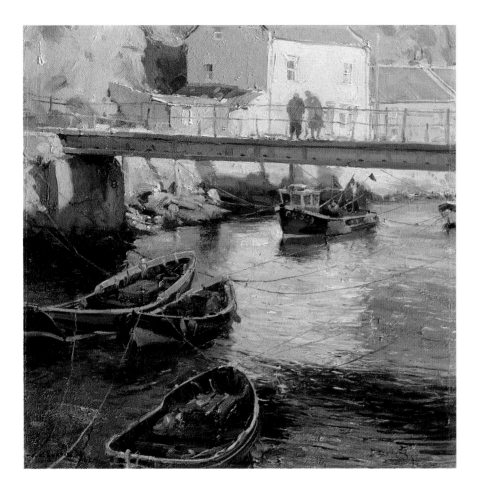

Conversation on the Bridge
Oil on canvas, 40.5 x 40.5 cm (16 x 16 in)
I greatly enjoy the challenge of capturing a particular quality of light, and I am always interested in seeing how other artists tackle similar subjects.

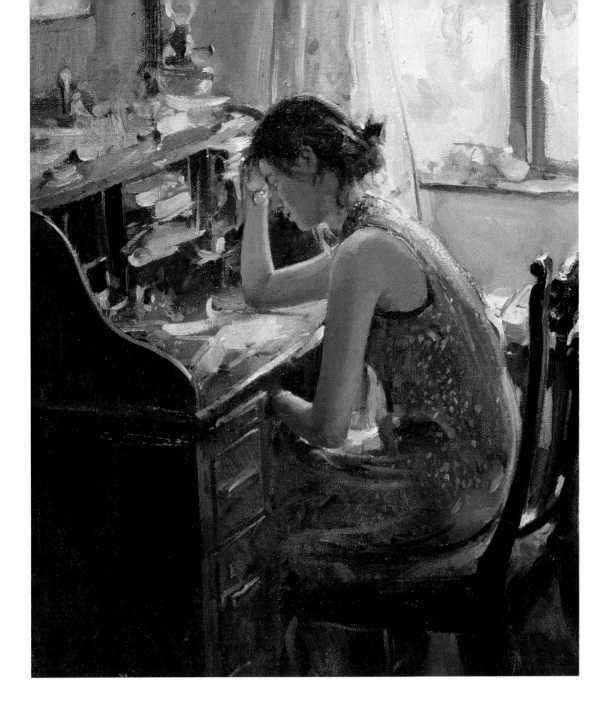

Essential Equipment

There is an extraordinary range of equipment available for oil painting, and when you begin using the medium it is tempting to think that a wide choice of paints and other materials will help you produce successful results. Indeed, this assumption might be strengthened if you happen to know any professional artists and have looked around their studios. Mine is the same. I have a lot of equipment. This is party the result of accumulating different pochade boxes, easels and other items over a period of more than 40 years of painting. But also, as you will see, it is because I need a large variety of equipment to suit the way I work – particularly the *plein-air* work.

However, if you are just starting to paint in oils I would suggest that you keep the materials and equipment to a minimum. A huge choice usually creates more problems than advantages. Interestingly, oil paint was the first medium I used.

Jacqueline Reading
Oil on canvas, 51 x 40.5 cm (20 x 16 in)
I seldom use more than about eight colours in a painting. Generally a limited palette creates greater harmony and impact.

That beginner's set I received as a 12-year-old, like all such sets, contained more colours than were necessary, and I soon discovered that results were far more effective if I restricted the number of colours and kept everything simple.

It was a good lesson to learn, and although I now use a few more colours, I still keep to quite a limited palette. This is something I would always advocate. So my advice to anyone starting in oils is to stick to the essentials: a small selection of paints and brushes, some low-odour thinners and some suitably primed boards or canvas panels. All you really need in the way of colours are two reds, two blues, two yellows and a white – perhaps specifically cadmium red and permanent rose (though use this sparingly; it is a very strong colour), cerulean blue and French ultramarine, lemon yellow and cadmium yellow, and titanium white. This selection includes a light and a dark version of each of the primary colours, and therefore theoretically provides scope to mix a large variety of colours. However, I would also suggest adding a couple of earth colours – such as raw sienna and burnt sienna. For brushes, try a large and a small round-bristle brush, and a large and a small flat or filbert type. Gradually, as you gain confidence and skills, you can add other materials and equipment to help you develop the effects you require for your particular style of painting.

Paints

Oil paints are made from organic or synthetic pigments, which are ground and mixed with a binding agent such as linseed oil. The colours vary in their characteristics and qualities: they can differ in being either opaque or transparent, for example, or in their degree of permanency or tinting strength. Similarly, the same named colour – say raw sienna – can look and handle quite differently from one brand to another. The process of finding exactly the right colours takes time, and relies both on experience and on trial and error. The colours in my palette are from various brands that I have tried out over the years and come to love.

I usually have a total of 17 colours available in the studio. This may seem a lot, but although all of these are set out on the palette I will probably only use about half of them. Naturally the exact choice depends on the subject matter and the sort of effects I wish to create. These colours are: titanium white, a dense white that I think handles better than either zinc or flake white; cadmium orange; cadmium red; permanent magenta; cobalt violet, a lovely gentle colour that I often use in mixes; viridian hue (student-quality), a useful vibrant green; terra verte, an earth green; burnt sienna; raw sienna – Winsor & Newton's is the darkest I can find; cerulean blue; French ultramarine; transparent gold ochre; Indian yellow; Winsor lemon; buff titanium; Naples yellow; and Naples yellow light. Occasionally I also use viridian (artists' quality) when I want a more subtle green of this type. You may notice that there is no black in my palette. I use a mix of burnt sienna and French ultramarine to create a dark that is as near to black as I can get, yet still transparent.

For working outside with a small, 15 x 20.5 cm (6 x 8 in) palette, I choose a more restricted range of colours – about two-thirds of those listed above: titanium white, cadmium red, cadmium orange, cobalt violet, viridian, cerulean, French ultramarine, raw sienna, lemon yellow and buff titanium. This selection gives me plenty of scope for small oil paintings, and for sketching in oils.

Lifeboat Day, Staithes
Oil on board, 25.5 x 30.5 cm (10 x 12 in)
It is important to use good-quality paints, and therefore worth experimenting to find the best brands and colours for your type of work.

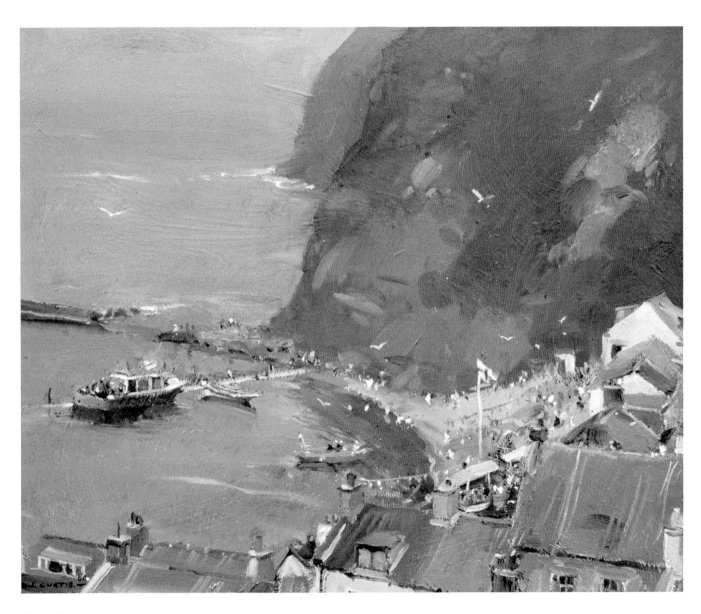

Brushes

My preference is for short-hair brushes, and mostly I use filberts and short flats. I like the bristle of a brush to create a sort of knife-edge effect, which helps when painting more defined strokes and passages. For me, short-hair brushes offer more control. Longer-haired brushes, which seem to be very popular these days, have a very springy feel, and in time they tend to splay out like a shaving brush.

I have about 40 brushes available in my studio. These include flats and filberts from the Pro Arte Series A, the Daler-Rowney Bristlewhite and the Winsor & Newton Artists' ranges, from size No. 1 brushes through to No. 14. When painting outside I use a smaller selection of brushes, about eight in all, ranging from a No. 1 to a large brush, 2.5 cm (1 in) wide, which is ideal for washes and blocking in. As well as filberts and flats, which incidentally are also sometimes known as brights, you will find that you can buy round bristle brushes made from either natural hog hair or synthetic hair. Again, from experimentation and experience, it is a matter of finding the best product for your style of work.

Cleaning brushes is not my strong point – I would much rather spend time painting! Essentially all I do with used brushes is leave them in a bowl of turpentine. When I need some clean brushes for a new painting session, I simply swish them around to rinse off the excess paint and then thoroughly wipe them on an absorbent rag. However, since my brushes sustain a good deal of wear and tear, I expect to replace them frequently.

This said, brushes are expensive and of course it is worth taking some care over them if you can. Because I paint almost every day, my brushes are never left in turpentine for long periods. But for those artists who only have the time to paint now and again, I would suggest that you thoroughly clean the brushes after use and then place them in a jam jar or similar container, bristles upwards, until you are ready to start work again.

Forgotten Corner, Kentallen, Argyll
Oil on board, 25.5 x 30.5 cm (10 x 12 in)
I prefer short, flat bristle brushes, since these allow more control and a wider range of expressive marks.

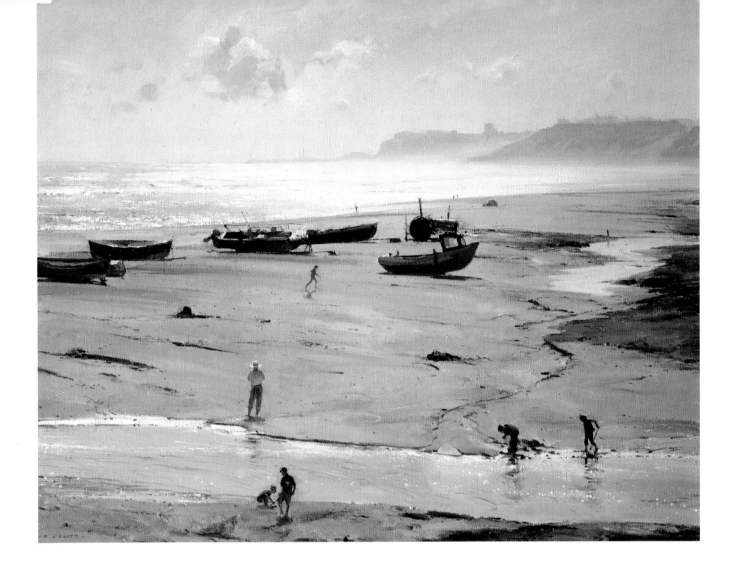

Painting Surfaces

Of the various materials involved in creating an oil painting, it is generally
the type of canvas or board support used that is the most influential factor
in helping the artist to express successfully what he or she would like to say
about the subject. It is a matter of choosing a surface that will enhance those
qualities in the subject that you want to bring out. Again, the ability to do
this is something that comes from the experience of having tried out different
possibilities – in this case by exploring the potential of various types of prepared
boards, canvas boards and, of course, stretched canvases.

There is a good choice of stretched canvases available, in both cotton and linen
surfaces. You can also buy lengths of canvas cut from a roll, or even a whole roll
if you wish, and use this to stretch your own canvases. Stretcher pieces, wedges
and other necessary items can be bought at art shops. Most canvas comes ready-
primed with two coats of acrylic or oil-based primer. However, some artists
prefer to buy unprimed canvas, so that they can prepare it in a particular way.

I always paint on linen canvas, and there are several grades of surface that I
use: a fine-grained surface for portraits and other subjects that require smooth
passages of colour, detail and controlled work; a medium-textured surface for
landscapes, as used for instance in *Whitby Headland from Sandsend, North
Yorkshire* (above); and a rough weave for large, expressive ideas. I also use canvas
boards, which are made by mounting canvas on to hardboard or another type of
stout board, see *The Fish Market, Venice* (page 26).

Whitby Headland from Sandsend,
North Yorkshire
Oil on canvas, 61 x 76 cm (24 x 30 in)
For this landscape subject I used a
medium-textured linen canvas prepared
with several coats of acrylic primer.

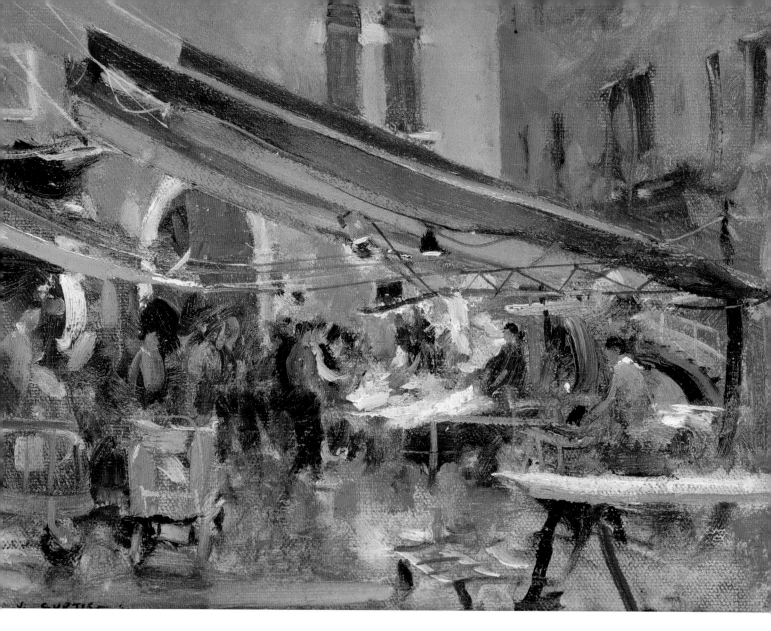

The Fish Market, Venice
Oil on board, 18 x 25.5 cm (7 x 10 in)
Canvas boards are ideal for small, on-site paintings like this.

I like the primed surface of my canvases to be fairly thick, so when I buy canvases I generally add a further coat of acrylic primer on top of the ones already there. Sometimes, for the rough-surfaced canvases, I also apply a coat of oil-based primer, to give a slightly less dry surface. I find this is particularly helpful for large seascapes, allowing me to work with more flexible strokes.

Outside, I usually paint on hardboard panels, which I prepare myself. Obviously, with the constraints of time, light and other factors, the scale of work on site has to be fairly small, perhaps no larger than 30.5 x 40.5 cm (12 x 16 in), and it is also preferable to have a surface that is reasonably sturdy and will stand a few knocks. A gesso-primed hardboard panel is ideal for this purpose, and this is what I used for *Figures on the Beach, Staithes* (right).

I normally prepare a whole batch of these panels at the same time, aiming to give myself a good choice of sizes, surface textures and tones. I work on the smooth side of the board, preparing it first with a coat of acrylic primer, then with a coat of gesso primer and texture paste mixed together. For most boards the primer and texture paste are mixed in equal proportions, but I use more texture paste on some boards to produce a slightly rougher surface. Then, to ensure a dense, white finish, I add a further coat of gesso primer and let the boards dry.

Some boards are left white, but the majority are painted with a neutral-colour turpsy wash over the entire surface. The purpose of this is twofold: to block out the intimidating white surface; and to create an underpainting that will give a tonal unity to all the subsequent brushwork. I use different colours for the washes – perhaps a mix of French ultramarine and raw sienna for a cool, neutral tone; or French ultramarine, raw sienna and burnt sienna for a warmer tone. Most of the boards are left flat to dry, but some are propped up so that the wash runs down and produces a more granular surface finish.

I take a variety of boards with me when I go out painting, which enables me to select the best surface texture and colour for the subject I have in mind. The white boards are useful for those paintings in which I want to employ a 'rub-out' technique, as explained on page 14.

Palettes and Ancillary Equipment

The traditional palettes for oil painting are made of mahogany or a similar lightweight hardwood, and they are available in kidney, oval and rectangular shapes, as well as different sizes. However, not all artists use a conventional palette. There are some who mix their paints on an old desktop, for example, or perhaps use an offcut of board, treated with linseed oil to seal the surface. Generally the type and size of palette will reflect the scale and nature of the work being undertaken.

As with most of my equipment, I have a selection of palettes – of different sizes to fit my range of pochade boxes (portable painting boxes) – and also several in the studio. There is one kidney-shaped palette, while the rest are rectangular, the shape I prefer. But contrary to the common image of the artist

Figures on the Beach, Staithes
Oil on board, 20.5 x 30.5 cm (8 x 12 in)
Hardboard is a sturdy surface for *plein-air* work and it can be prepared with a variety of coloured and textured grounds.

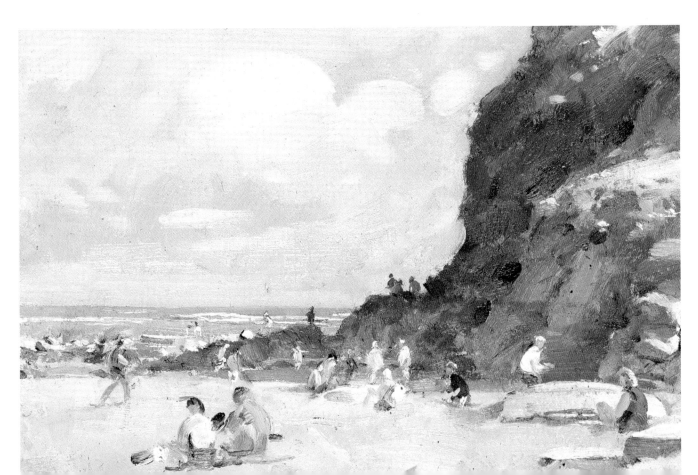

at work, I never hold the palette: it is always on a table beside me or, when I am painting outdoors, fixed to the box easel or pochade box. This is because I like the freedom to step back from the work and move around a lot, which is more difficult if you are holding a heavily laden palette.

I confess that I am not very good at cleaning palettes. In fact, I probably never clean them! When eventually the palette gets too laden with paint to use, I throw it away and start with a new one. Because I paint all the time, there is an advantage in leaving unused paint on the palette and having some of my favourite mixes ready to use. But if you only have time to paint now and then, obviously it is sound practice to clean the palette when you have to stop work. Scrape off the excess paint and wipe the palette with a turpsy rag, and then some paper towels.

Easels

Apart from any small, pochade-box paintings that you might do outdoors, you will find that some kind of easel is necessary to hold the canvas or board in a fairly upright position while you work. It is also an advantage if the easel is adjustable, allowing you to tilt it slightly forwards or backwards to counter any problems with light reflecting on the surface of the oil paint. The choice of easel will mostly depend on the size and type of work you do.

Many artists have more than one easel, to suit different approaches in the studio and outside. The available range includes various H-frame, A-frame, radial and studio easels, as well as lightweight folding easels for sketching, and box easels. The latter is a good compromise if you only want to buy one easel that will suit both studio and *plein-air* work.

As explained on page 30, I often use a box easel when I am painting outdoors. In my studio I have a large H-frame easel, a tilting radial easel and other radial easels that I can work at. There is usually work in progress on most of these, and normally during the day I will spend time on more than one painting.

Thinning Agents

There are a number of different solvents and mediums that can be used to dilute the colour, alter its handling characteristics and speed up the drying time. These include genuine turpentine, turpentine substitute (or white spirit), low-odour solvents and linseed oil for thinning and mixing colours; poppy oil for increasing the drying rate, particularly with whites and pale colours; and gel mediums, such as Oleopasto, for impasto and texture work.

My advice is to use all diluents and mediums with restraint. When I have been tutoring courses I have noticed that students are often too liberal in their use of thinning agents, and in consequence they lose control of the work and limit their ability to achieve strong tonal contrasts.

When I need to thin colours in the studio I use a low-odour solvent such as Sansodor (Winsor & Newton). I prefer this type of solvent because I greatly dislike the smell of pure turpentine – I find it overpowering when used for prolonged periods in a confined space, even with good ventilation. However, I am always very sparing in the use of thinning agents. In fact, I never use linseed oil, because in my view modern paints contain enough oil to begin with. I do thin the colours a lot for the initial wash and underpainting, but after that I prefer the

Garden Study, Gibdyke House
Oil on board, 30.5 x 20.5 cm (12 x 8 in)
For small paintings outside I usually work
from a pochade box or lightweight box easel.

paint to be less fluid, which allows me to make some superimposed, loaded
impasto strokes where necessary.

This is the approach I always encourage. It is also important, I think, to
exclude the use of white in the early stages of a painting. Initially, what you are
trying to avoid is limiting the transparency and tonal strength of the colours by
making them too creamy and slippery. The only other medium I sometimes use is
Liquin (Winsor & Newton), which I find helpful for mixing glazes (see page 36).
Other useful ancillary equipment includes a dipper – a small round container for
turpentine that clips onto the side of the palette – and plenty of absorbent rags
for cleaning brushes.

Painting Outdoors

The majority of my paintings are made on the spot, or at least started outdoors,
and here again I have a variety of equipment to suit different situations and
opportunities. If the light, weather conditions and subject matter are such that I

feel able to tackle a fairly large painting, say up to 40 x 50 cm (16 x 20 in), then I will work at my box easel. This contains all the materials that I need for painting – paints, brushes, turpentine, palette, painting boards and so on. Additionally, I usually take a fishing stool to sit on, and this incorporates a bag for other useful items, including a flask of coffee! The disadvantage of a box easel is that it is quite heavy to carry for any distance, although fine if you can work not far from the car – in which, incidentally, I normally have a selection of prepared boards of different sizes and ground colours. For travelling light, the best idea is a pochade box, which is essentially a small wooden box with compartments for paints, brushes and other necessary materials, plus a palette and one or two painting boards, which fit into the lid. There are various sizes of pochade box, and obviously the size of it determines the scale of the work.

I have a range of these boxes, about ten in all, starting with a small, 15 x 20 cm (6 x 8 in) pocket-sized box. I keep the boxes in strategic places – in the car, in my boat and at my cottage in Staithes – so that there is always one available if I see something that I must paint. I love working outside because the approach has to be immediate and instinctive, and I think this often leads to better paintings.

Rooftops and the Cliffs, Staithes
Oil on canvas, 51 x 51 cm (20 x 20 in)
Staithes has always been one of my favourite painting locations. With its variety of viewpoints and changing light and tides, it offers an endless supply of exciting subjects to paint.

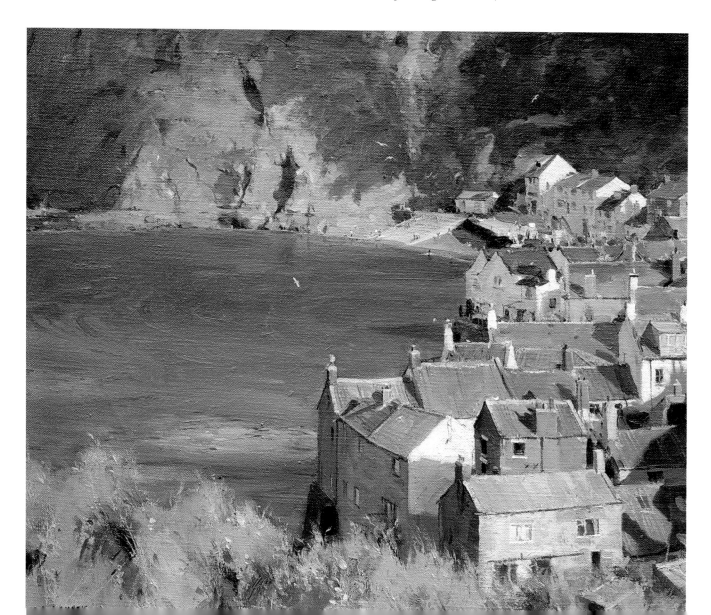

Developing Skills

Confidence in using a wide range of oil painting techniques is something that artists acquire gradually, as they gain a greater understanding of the medium and experience tackling various types of subject matter and interpreting specific qualities and effects. In time, the choice and use of different techniques becomes an instinctive process. But initially, as in all aspect of developing an individual and assured way of painting, progress depends on a willingness to experiment and a commitment to practise and persevere.

Alla Prima

Derived from the Italian phrase for 'at first', *alla prima* is the technique of painting directly onto a prepared support to produce a finished, or virtually finished, work in one session. This is the method I use when painting outdoors, working on a small scale and applying the colours in a speedily conceived, 'one-hit' manner, with little or no subsequent modification. I like the vigour and spontaneity of such paintings. They often capture the mood and sense of place far more effectively than a larger, more considered work produced in the studio.

Meadowsweet by the Lake (above) and *The Hidden Inn, Nottinghamshire* (page 32) are both examples of the *alla prima* approach. For me, the little pub in *The Hidden Inn, Nottinghamshire*, which somehow reminds me of the Potwell Inn in H G Wells's *History of Mr Polly*, was inspirational – a tiny, secluded jewel among all the greenery. I chose a dry 30.5 x 25.5 cm (12 x 10 in) board that had already been prepared with an initial wash made from French ultramarine and raw sienna, and painted the scene quickly, mainly using hard-edged, staccato strokes. At the bottom of the painting, for example, you can see one large brushstroke, dragged from the centre outwards, which picks up the tooth of the board and suggests the texture of the gravel surface.

Meadowsweet by the Lake
Oil on board, 25.5 x 35.5 cm (10 x 14 in)
Most of my boards are prepared with a mid-tone oil 'wash' made from French ultramarine, raw sienna and burnt sienna.

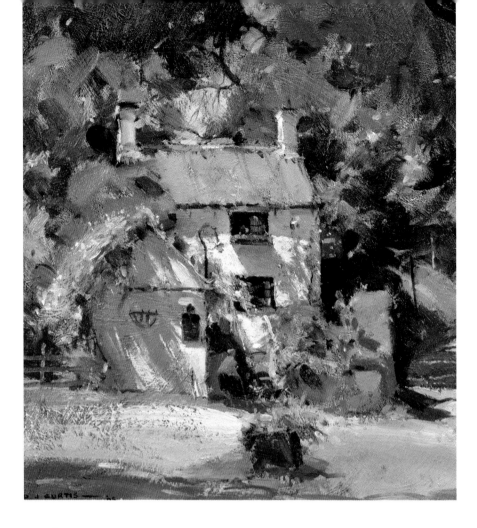

The Hidden Inn, Nottinghamshire
Oil on board, 25.5 x 30.5 cm (10 x 12 in)
I love the thrill of this type of painting, which requires speed and confidence to capture the scene in a very direct 'one-hit' manner.

Underpainting

The white primed surface of a board or canvas can be rather inhibiting, and in fact is seldom the best starting point, particularly if you want to work tonally. Consequently, it is a good idea to begin with an underpainting. This should be made with thin paint, applied with a loose technique, to establish a mid-tone reference to work from.

Some artists like to roughly block in an underpainting that also indicates the main shapes within the composition, but I normally start with a simple, overall wash of colour that can be left to dry or partly dry, or worked into while it is still wet. My methods for preparing boards and canvases with the initial ground colour or underpainting are explained in more detail on page 66.

I usually choose a dry underpainted surface for subjects that involve fleeting lighting conditions, as in *Sharp Spring Sun, Staithes* (top right). The underpainting provides a useful tonal value to work from, so helping in the judgement and control of the various tonal qualities as you subsequently develop them. For *Garden Study, The Red House, Mendam, Suffolk* (right) I used a board that had been prepared with the initial wash the day before. I had this particular location and subject in mind, and knew that there would be subtle variation of lights and darks with soft-edged shapes. These effects are best achieved on a surface that is still slightly wet and workable.

The third option, starting with a wet underpainting and rubbing out the white areas with a rag, is demonstrated in *Churchyard, Misson, Nottinghamshire* (far right). The white of the building on the right was created in this way. Note also that when working on a wet surface you can produce really juicy, blended strokes, such as that used for the church buttress on the extreme left of the painting.

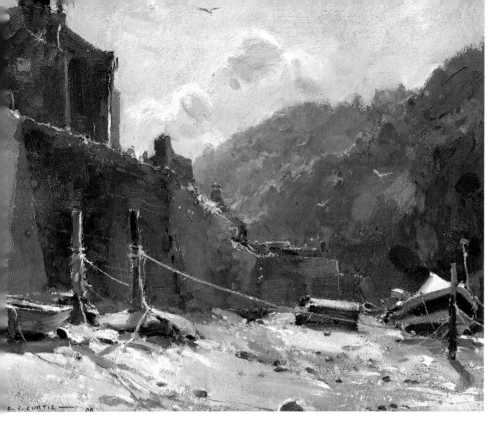

Left: *Sharp Spring Sun, Staithes*
Oil on board, 25.5 x 30.5 cm (10 x 12 in)
When tackling a particular light effect the initial preparation of the canvas or board is very important. For fleeting light conditions, such as in this subject, I usually choose a dry surface that has been prepared beforehand with a mid-tone ground.

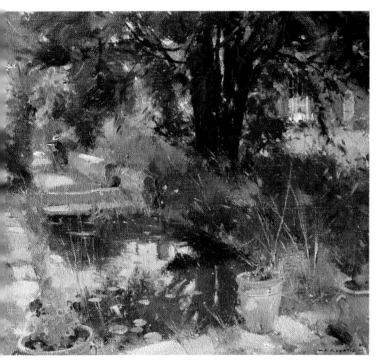

Above: *Garden Study, The Red House, Mendam, Suffolk*
Oil on canvas, 35.5 x 40.5 cm (14 x 16 in)
I often let some of the underpainting show through, as this helps in creating greater unity in the painting.

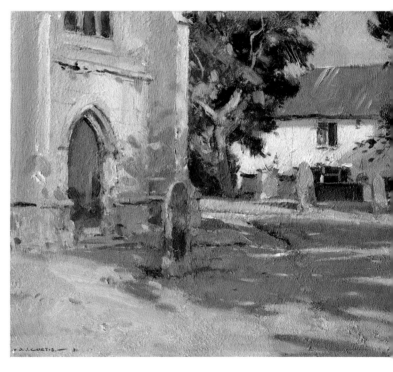

Above: *Churchyard, Misson, Nottinghamshire*
Oil on board, 25.5 x 30.5 cm (10 x 12 in)
Where there are strong highlights or large areas of white in a subject I prefer to start with a wet underpainting and then immediately rub out the white areas with a rag, as with the house in this painting.

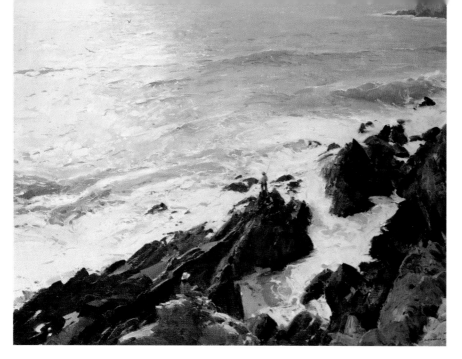

Seascape, Coast of Anglesey
Oil on canvas, 61 x 76 cm (24 x 30 in)
Especially when working on a large scale in the studio, I follow the traditional oil-painting process of using increasingly thicker, oil-rich paint as the painting develops.

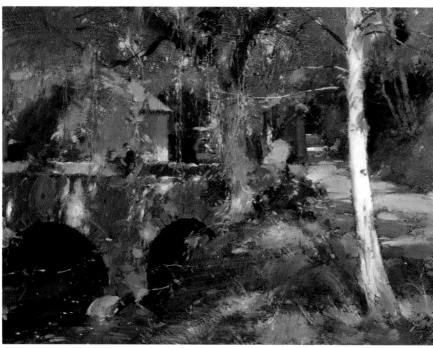

The Lane to Stone Mill
Oil on board, 30.5 x 40.5 cm (12 x 16 in)
One of the great strengths of oils is that you can build up surface textures and effects with bold, juicy brushstrokes.

Fat over Lean

This technique applies principally to paintings that are built up in layers, rather than *alla prima* work, which relies on a direct, 'one-hit' approach. As explained on page 17, thin (lean) paint dries faster than thick, oil-rich (fat) paint, and so it is important to begin with colour diluted with turpentine. Then, as further layers are added, successively less turpentine is used, resulting in thicker paint containing an increasing proportion of oil.

I always start with an underpainting applied as a wash of colour, and then I gradually work with thicker paint to develop the textures and effects I need. This was the process I used for *Seascape, Coast of Anglesey* (top), a large seascape in which I rubbed into the initial wash with a rag to establish the glinting light over the sea, and also the other main highlights. In the foreground, by contrast, I used

big stabs of colour to build up the various tonal changes, and to suggest the ruggedness of the rocks.

Similarly, in *The Lane to Stone Mill* (opposite, bottom), you can see how I have built up the different surface effects with quite bold, juicy strokes worked over the underpainting. I remember the pleasure of painting the light trunk of the silver birch tree on the right, and then blocking in the darks all around it. But as always with this technique, it was a matter of deciding how far to go in developing the painting while at the same time maintaining a strong sense of spontaneity and vigour in the work.

Blending

Here, the colours are worked wet-into-wet or wet-against-wet so as to create subtle changes of colour or soft, diffused edges. This is an ideal technique for painting water and reflections, as shown in *Time for Reflection* (below right). I also use it quite a lot for general areas of foliage where great detail is not required, such as can be seen in the middle ground area, behind the bench, in *Monks Mill, Scrooby, Nottinghamshire* (below left). Particularly in this case, I think you will agree that what might have been a very dull area is in fact quite an interesting one, due to the variegated effect of the blended colour.

You can blend colours by using a bristle brush to drag and merge a wet or tacky colour into an adjacent one, or you can paint one colour over another. A favourite blending technique of mine involves holding the loaded brush almost vertically and then pushing down and outwards to create a soft, feather-edge result.

Below left: *Monks Mill, Scrooby, Nottinghamshire*
Oil on canvas, 51 x 46 cm (20 x 18 in)
Here, I have used a blended effect to add interest to the foliage in the central area of the painting.

Below right: *Time for Reflection*
Oil on board, 30.5 x 25.5 cm (12 x 10 in)
Due to the particular character and consistency of oil paint, colours can be blended together with immense control. Blending is a very effective technique for painting water and reflections.

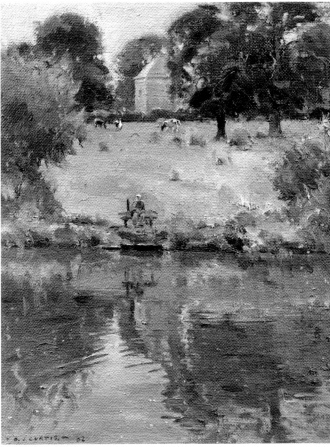

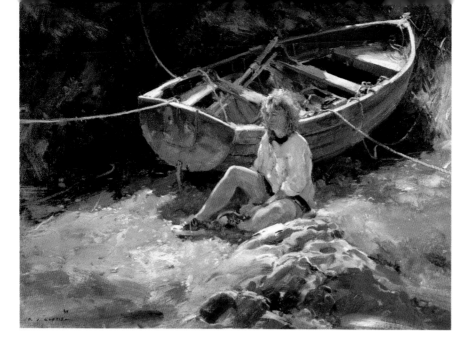

Helen by a Small Boat
Oil on canvas, 51 x 61 cm (20 x 24 in)
I often apply a glaze to lessen the impact of
an area that is beginning to look too dominant,
and that is how I treated the rocky,
background section of this painting.

Glazing

Glazing is a particularly useful technique for unifying passages in a painting that
have become too fussy or fragmented, and equally it is the ideal method to use
when you find that a colour or an area is too dominant within its context. A
glaze is a thin, transparent film of paint applied over dry colour to modify its
appearance or impact in some way. You can make a glaze by thinning paint with
glaze medium or, as I do, thinning with some turpentine or Liquin mixed with
retouching varnish.

The colours I most often use for glazing are transparent gold ochre, French
ultramarine, Indian yellow and sometimes permanent magenta. Note that these
are all transparent colours, allowing detail underneath to show through. I apply
the glaze with a large, clean brush, using broad strokes and avoiding any
reworking. I regard the technique as rather like the unifying wash that I might
employ in a watercolour. Paintings in which I have used glazing include *Helen by
a Small Boat* (above), in which I applied a glaze to the whole of the rock surface

Old Forge Interior
Oil on canvas, 50 x 70 cm (19¾ x 27½in)
Here again I felt that some of the dark areas in
the painting were too strong, so I subdued
them by applying a thin glaze made from
French ultramarine, transparent gold ochre
and a touch of burnt sienna, mixed with
retouching varnish.

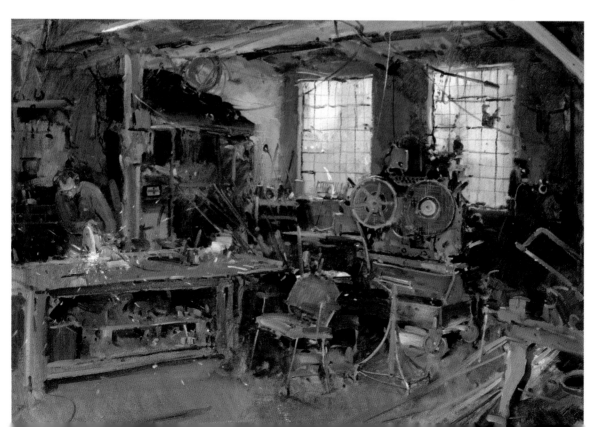

at the back to help subdue that area and in turn bring the boat forwards, and *Old Forge Interior* (below left), where again I wanted to push back some of the darks, particularly behind the man on the left, and so create a greater sense of depth.

Impasto

The use of thickly applied paint, to create obvious brushmarks and surface textures, is known as impasto. I use this technique when I want to make a bold, loaded statement, with the colour left proud of the surface and without any further modification or blending. It is a good technique for placing the lightest lights and similarly any really strong dark areas. Impasto marks should look confident, exciting and painterly.

I have employed this technique quite extensively in the foreground area of *Cliff Forms, Kettleness, Yorkshire* (below), where the thick, horizontal brushstrokes help create a feeling of space and recession. The direction of the brushstrokes is always important in contributing to the sense of movement and form in a painting. Notice, for example, that I have used a different flow of brushstrokes to model the hillside in this painting.

Cliff Forms, Kettleness, Yorkshire
Oil on board, 20.5 x 25.5 cm (8 x 10 in)
Bold, directional brushstrokes can be very useful for suggesting a sense of movement or recession. Note the strong, horizontal brushstrokes in the foreground of this painting.

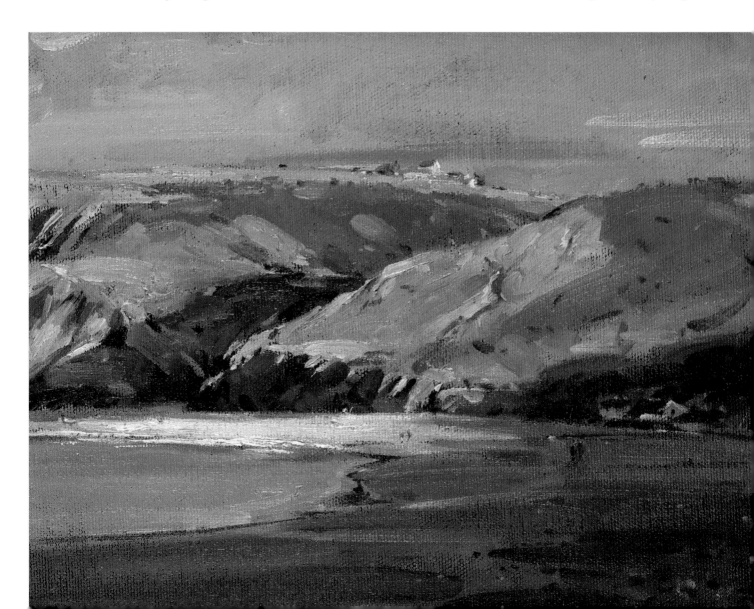

Scumbling

Scumbling is a very effective technique when you want to block in a large area of colour loosely and quickly, and it is also useful as a means of working fresh colour over dry paint to create a more atmospheric or diffused result. The paint for scumbling should be relatively dry, and the technique for applying it involves using the brush with a scrubbing motion (as if you were cleaning the brush), working with zigzag, concertina-like strokes. Choose a large brush and apply the paint in a free, vigorous manner to give a broken-colour effect.

Scumbling produces a distinctive paint quality, as shown in the rocky, background area in *Helen by a Small Boat* (page 36), which was painted in this way. I also use a scumbling technique when I am blocking in the underpainting for a subject. Working quickly, my aim is to achieve an impression – a sort of ghost effect – of the main shapes, colours and tones.

Other Techniques

Naturally there is a whole variety of different brushwork effects that can be incorporated into a painting. The range and character of the different marks and textures involved will depend largely on the size and shape of the brushes used, and precisely how the paint is applied and manipulated. In *Cottage Backs and Boulby Cliff* (below) for example, the range of brushwork techniques includes blended strokes, in the sky and sea areas; blocks of colour, for the buildings; little stabs of colour, for highlights and other features; and broad, sweeping strokes, such as the one right across the bottom edge.

In paintings such as *Windbreakers, Sandsend Beach, North Yorkshire* (above right) and *The Beach at Runswick Bay, North Yorkshire* (below right), which include groups of figures or similar details, I usually finish with a certain amount

Cottage Backs and Boulby Cliff
Oil on board, 20.5 x 30.5 cm (8 x 12 in)
Here I have used various types of brushstrokes to shape and suggest the different surfaces – the buildings, landforms, sky and so on.

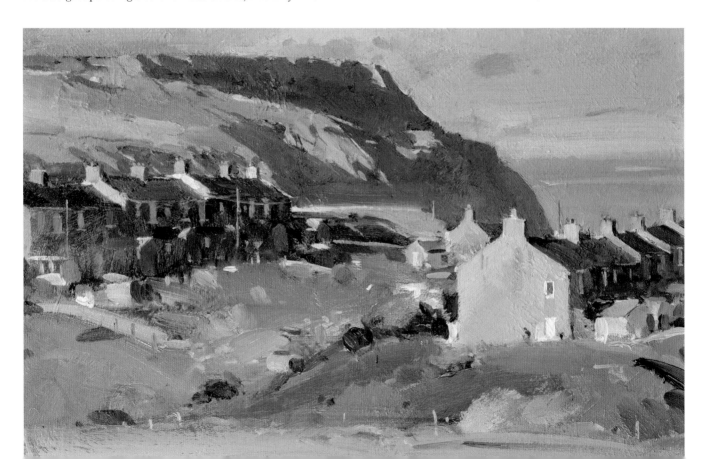

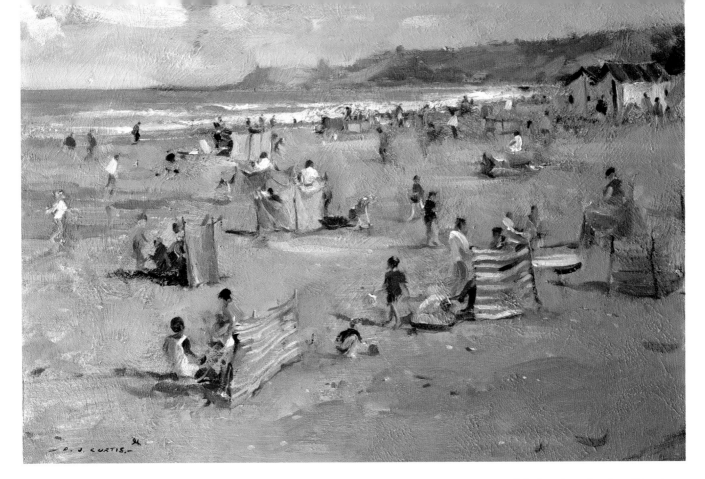

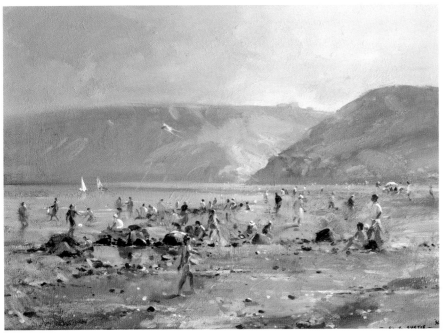

Above: *Windbreakers, Sandsend Beach, North Yorkshire*
Oil on board, 25.5 x 35.5 cm (10 x 14 in)
Sometimes at the end of a painting it is necessary to tidy up figures and other details with a certain amount of overdrawing or line work.

Left: *The Beach at Runswick Bay, North Yorkshire*
Oil on board, 25.5 x 35.5 cm (10 x 14 in)
Whenever figures are included I try to ensure that they look part of the scene, and I paint them in the same style as the rest of the work.

of overdrawing and line work to tie everything together and ensure that the painting 'reads' successfully. In some paintings I may need to reaffirm certain directional lines, add ropes and rigging lines to boats, and so on. I use a No. 1 or No. 2 short, slightly worn bristle brush for this, being careful not to overstate anything and ensuring that any additional lines and marks are in keeping with the rhythm of the painting as a whole.

2 Design principles

While skills in handling oil paint and applying appropriate techniques are essential, they are not sufficient in themselves to create a good painting. Also fundamental to the success of a painting is its design and structure – the strength of the underlying drawing and, in turn, the interest and effectiveness of the composition. A painting can be technically very sound in the way that the artist has used colour and expressive brushwork, but if the design is weak, inevitably the overall impact of the work will be seriously undermined.

I strongly believe that gaining experience and confidence in drawing should be the first concern of every artist. Not only is it through drawing that we develop observational skills, but our drawing ability also enables us to record, inform and plan ideas, and of course to set down the framework for a subject before we start painting. Moreover, it does not stop there, for drawing is an inherent part of the painting process. Often a brushmark is delineating or defining, as much as it is adding colour, texture and other qualities.

In an age of digital cameras it is very tempting to think that we can bypass the need to make drawings simply by taking lots of photographs. Obviously photographs are useful in certain circumstances, but what they cannot do is edit something extraneous out of a scene, isolate key features or indeed capture what we feel about the subject. A sketch works much more successfully, for with just a few skeletal lines it can show the basic block-like elements that are needed to assess how well the subject will work as a composition, and so give a starting point for the painting.

Shattered Jetty, Port Mulgrave, Staithes
Oil on board, 40.5 x 30.5 cm (16 x 12 in)

Drawing and Observation

Developing an eye for a subject that has an exciting, original composition is something that is born of experience. It relies on the ability to observe and assess quickly, yet without missing the best possibilities, and this can only be achieved through practice. In turn, the process of looking in a thorough, analytical way will add to your understanding of different types of subject matter, and increase your skill in teasing out the maximum impact from the scene in front of you.

Again, drawing and sketching play their part because, by necessity, they involve observation. If you want to draw something convincingly you must first look at it, and try to understand it. In time, observing and evaluating becomes second nature, rather than a very conscious and deliberate process, and you may find that it is not so essential to start with drawings or sketches, although these are always valuable. Like me, when you paint *plein air* you may feel able to begin directly with a brush, having already judged the particular composition and qualities that you would like to include in the painting.

Whatever the subject matter, my advice is to avoid the obvious and search out the unusual and individual. Try not to reach a conclusion about the composition and content too quickly – give yourself what I would call some 'dither time'. Consider different viewpoints, and whether you feel there are any elements that should be simplified, exaggerated and so on. Remember, you do not always have to paint exactly what is there!

New Year's Eve '96, Misson
Oil on board, 25.5 x 35.5 cm (10 x 14 in)
People thought I was crazy when I started to paint this wonderful subject, full of atmosphere and interest, during a snowstorm!

Using a Sketchbook

I always have a sketchbook handy. Usually this is a little stiff-backed 15 x 20 cm (6 x 8 in) sketchbook that fits into my jacket pocket, which I use with a short stubby pencil for jotting down the main elements of a subject. I hold the pencil like a piece of chalk and draw from the wrist, with bold, sweeping strokes. In this way, using just a few lines – perhaps only ten or twelve – I can indicate the principal block shapes of the composition, with maybe a mark or two to place strategic figures. A quick sketch like this will tell me whether or not the idea is going to be successful on a larger scale for a painting – see sketch for *View from Cowbar, Staithes* (right).

Sketch for View from Cowbar, Staithes
Pencil on watercolour paper
15 x 21 cm (6 x 8 in)
A small, quick sketch like this helps me assess the composition and main tonal values of a potential subject.

View from Cowbar, Staithes
Oil on board, 30.5 x 40.5 cm (12 x 16 in)
From the pencil sketch I was confident that the composition would work successfully on a larger scale.

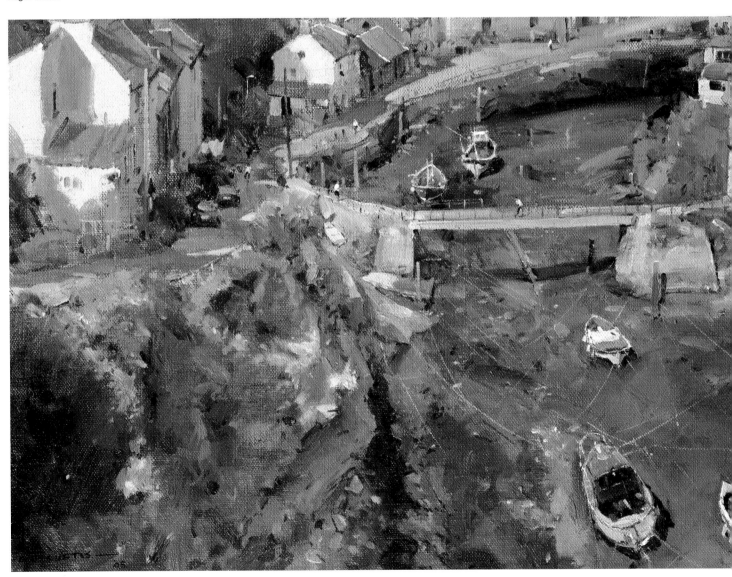

Alternatively, I sometimes make a small oil sketch on a piece of prepared board or a canvas board. For this I use my pochade box, working with a very limited palette of colours and, as in *Breezy Day on the Norfolk Coast* (below), develop the painting quickly, with expressive, bravura brushstrokes. Again, this gives me a sense of how well the subject will work as a painting, and I can use the sketch as the basis for a larger, more resolved version. However, I might make a careful pencil drawing rather than a quick sketch if the subject is very active or complex, and I know that the only realistic approach is to paint it in the studio. This pencil study, along with some photographs and my memory of the subject, will then serve as vital reference material for a studio painting at a later date.

Breezy Day on the Norfolk Coast
Oil on board, 18 x 25.5 cm (7 x 10 in)
Another useful form of reference is a small oil sketch, like this one.

Photographs

Like most artists I sometimes refer to photographs for certain forms of information, although as noted above I prefer not to rely solely on this approach. I think photographs can be useful as a prompt, as an *aide-mémoire*, but you should avoid copying from them. If used slavishly, the effect tends to show in the final painting – it invariably lacks the vigour and spontaneity of a work that is painted *plein air*. The quality that I strive for in all my work, whether painted outdoors or in the studio, is the sense of immediacy. My aim is for images that are dynamic, non-photographic and painterly.

I know several artists who prefer to use poor-quality, grainy photographs in preference to sharp-focused ones, because the former provide only a suggestion of the subject matter. This is ideal, for they provide just enough information to work from, while still requiring the artist to use some imagination. The temptation when referring to photographs is to get involved with too much detail. Therefore, if your photographs are really sharp, it is a good idea to look at them through half-closed eyes, to squint, so that you lose some of the definition and detail within the image.

Photographs are a particularly useful form of reference for architectural subjects, complex city scenes, figures and specific lighting effects. For example, when I am painting *plein air* I usually take a photograph of the subject matter when the light is at its best, in case the painting should not go according to plan or I have to finish it in the studio. Some of the figures introduced to help balance the composition in *Classic Car Rally, Brodsworth, Yorkshire* (above) were based on figures in photographs. The secret when doing this is to paint the figures – or any other detail derived from the photograph – with the same type of brushwork that you have used elsewhere in the painting. They must fit into the scene and look part of the whole.

Classic Car Rally, Brodsworth, Yorkshire
Oil on board, 18 x 25.5 cm (7 x 10 in)
As here, I often add figures from sketchbooks or other reference material, taking care that they are not too dominant within the overall composition.

Viewpoints

Whatever the intention when you come across a subject that excites and motivates you – whether you want to paint it on site or gather the necessary information for a studio painting – decisions about the viewpoint will play a key part in influencing the painting's ultimate success or failure. As I mentioned on page 42, it is always worth allowing yourself some 'dither time' to check the various possibilities regarding the viewpoint, which will in turn affect the composition and also the shape and scale that will work best for the painting.

Moving just a few feet to the left or right can make all the difference to the composition and impact of a scene. Similarly, if there is scope to do so, viewing the subject from a slightly higher – or conversely, slightly lower – vantage point often produces a more dramatic result. As I have stressed, the first thing to consider about composition is how successfully the main areas relate to each other and create a structure for the painting, which you should always aim to make visually exciting and original. Initially I think of the principal areas in terms of simple block shapes, and a small, quick sketch instantly shows how well these will work in terms of the composition.

There are occasions when you know immediately that a particular subject will make a strong composition. This was true with *The Chesterfield Canal at Drakeholes* (below), for example. Here, the design is relatively simple and

The Chesterfield Canal at Drakeholes
Oil on board, 25.5 x 30.5 cm (10 x 12 in)
Simple, bold compositions often work best. This one consists of just four shapes.

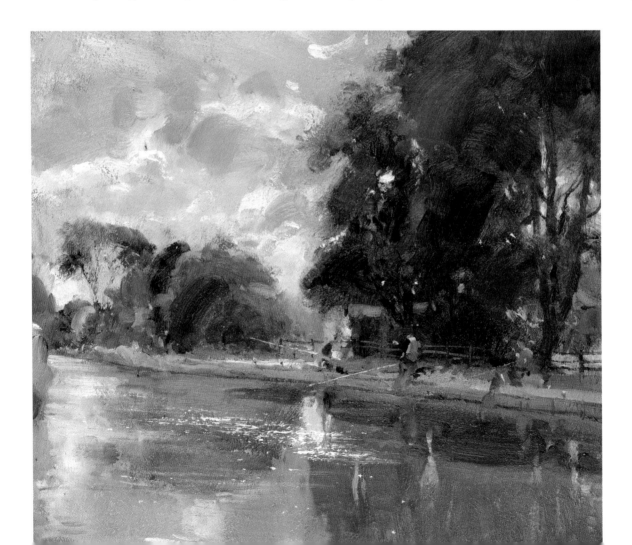

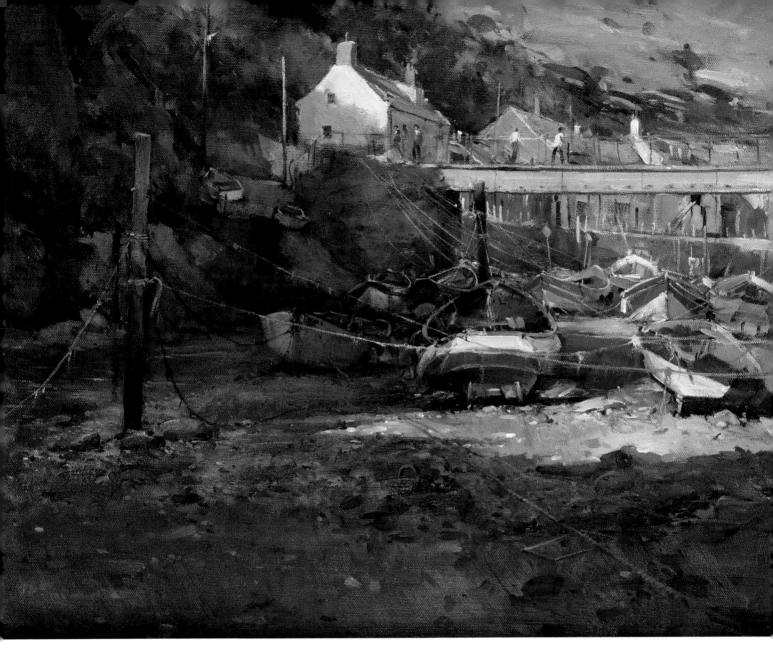

consists of just four main shapes: the dark mass of trees on the right, the sky
area, the distant line of trees, and the river. But it makes a very effective painting
that, like the scene itself, reminded me of Constable's oil sketches. In contrast,
there are other times when it is a matter of relying to a greater extent on your
experience in order to capitalize fully on the potential of the subject by selecting
or exaggerating certain elements, as well as using some imagination. Sometimes
within one scene there are several exciting possibilities for paintings, and perhaps
therefore several paintings.

 With a panoramic view it is often difficult to decide which part will make the
most successful painting. Again, the best approach is to assess and compare the
various options. It could be that a particular quality of light in a certain area will
influence your decision, which is often the case when I am painting at Staithes,
as in *Last Light in the Beck, Staithes* (above). Some artists carry a cardboard
viewfinder to help them 'frame' the subject and choose the best viewpoint.
Looking through your camera viewfinder will give a similar result. I use my
hands as a sort of viewfinder, holding them up in front of me and overlapping

Last Light in the Beck, Staithes
Oil on canvas board, 46 x 56 cm (18 x 22 in)
With a panoramic view it can be difficult to
choose which section will make the most
exciting composition. Here, I liked the strong
contrast between the light and dark areas.

them (rather like two L-shaped pieces of mountboard) and adjusting them to form a square or rectangular space between my thumbs and forefingers.

Additionally, of course, there can be practical considerations that will influence the choice of viewpoint. In a busy town, for example, the choice may well be restricted because of traffic or the need to find a quiet spot where you won't be constantly interrupted by inquisitive passers-by. Nevertheless, with luck you will still be able to find those all-important interesting block shapes.

Secluded Bay, Port Isaac, Cornwall
Oil on board, 25.5 x 30.5 cm (10 x 12 in)
I try to avoid the most obvious painting spots, but instead find somewhere that will give me a composition that is different and original.

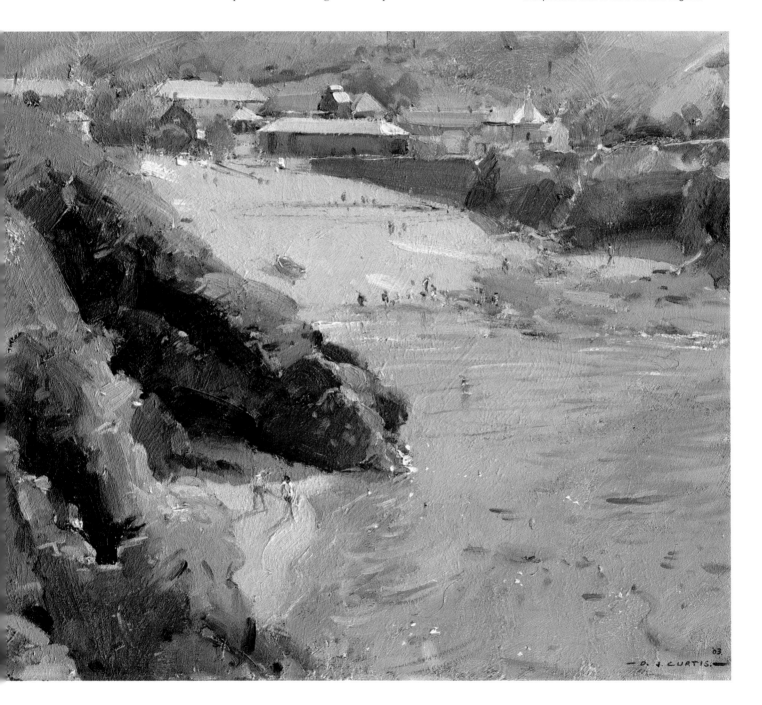

Balance and Movement

It is tempting to think that the more detail and realism you involve in a painting, the more people will admire it and respect the skill of the artist. I know this was something I once believed, in the early stages of my career. In fact, it is generally true that fussy, detailed paintings are far less interesting and effective than those in which the artist has selected from the subject matter and created some kind of order and harmony. The essence of a good painting is that it conveys a great deal – both factual and emotional – but with an economy of means. Equally, part of its attraction is that it leaves something to the viewer's imagination.

There are always certain things that one is aware of when considering the composition of a painting, although with increased experience I think this process becomes less deliberate and more intuitive. A composition will look awkward if something is too dominant in the centre. Interestingly however, as in *The Old Lifeboat Slipway, Runswick Bay, North Yorkshire* (below), an object placed slightly off-centre (in this case the yacht) can work very well. Incidentally,

The Old Lifeboat Slipway, Runswick Bay, North Yorkshire
Oil on board, 30.5 x 40.5 cm (12 x 16 in)
A composition in which a certain shape is repeated often works extremely well. Note the different triangular shapes in this design.

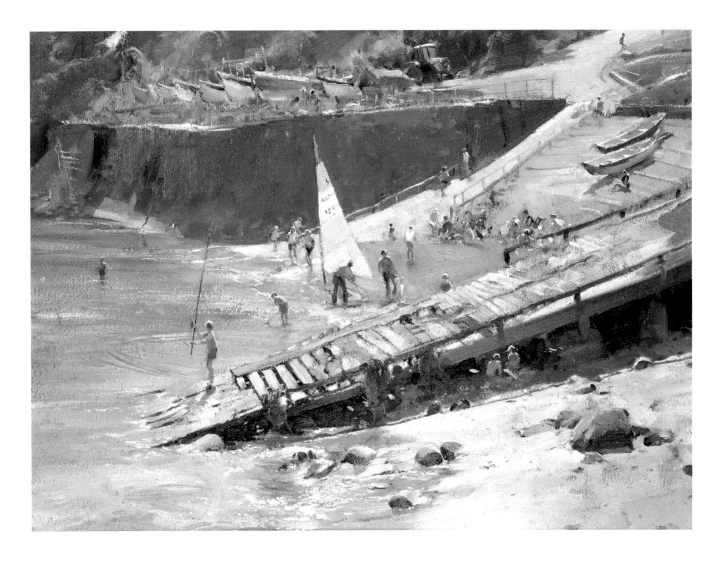

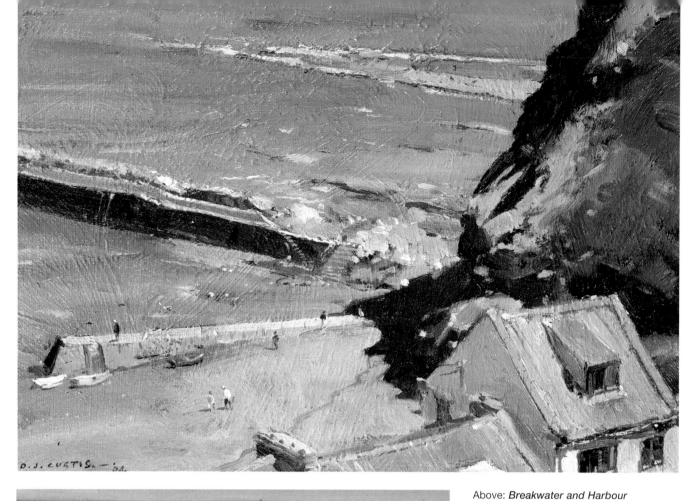

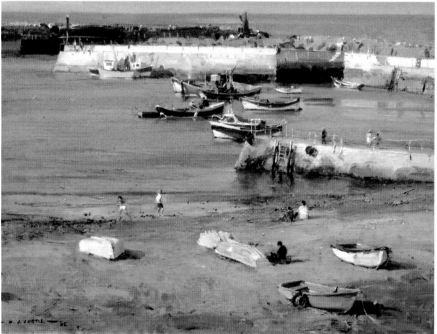

Above: *Breakwater and Harbour Wall, Staithes*
Oil on board, 15 x 20.5 cm (6 x 8 in)
I scrambled up a steep cliff to find this interesting viewpoint.

Left: *Fine August Day, Staithes*
Oil on canvas, 30.5 x 40.5 cm (12 x 16 in)
The attraction here was the high horizon and the strong, well-lit horizontals of the harbour walls, which were echoed by the boats on the shore in the foreground.

note how the strong directional lines in this painting add to the visual energy and dynamics of the composition, and also how effective it is to repeat certain shapes – for example the yacht, the harbour wall behind, and the slipway in the foreground, which are all triangular shapes. See also *Breakwater and Harbour Wall, Staithes* (top), in which, similarly, there is a high horizon and a powerful design formed from triangular shapes.

Making an Impact

It is very important not to repeat ideas, not to 'play safe' in every painting, for in my opinion this only leads to rather uneventful and dispirited work. However, while it is essential to express something different in every painting, this doesn't necessarily preclude returning to a subject or location that you have already explored if you think it still holds potential.

There are some places that I never tire of, and even at Staithes, where I have painted for many years, I still manage to find new, unusual and challenging ideas, although admittedly this does sometimes involve a certain amount of daring. To find the sort of viewpoint I wanted for *Breakwater and Harbour Wall, Staithes* (left), for example, I had to scramble up a steep cliff face and perch on a narrow ledge (do not feel you have to follow my example, however – only you will know what level of risk you are comfortable taking!). As you can see from many of my other paintings, including *Low Water, Staithes Beck* (below) and *Cliffs and Rooftops* (page 52), I like high viewpoints, which I feel add impact and drama to a scene.

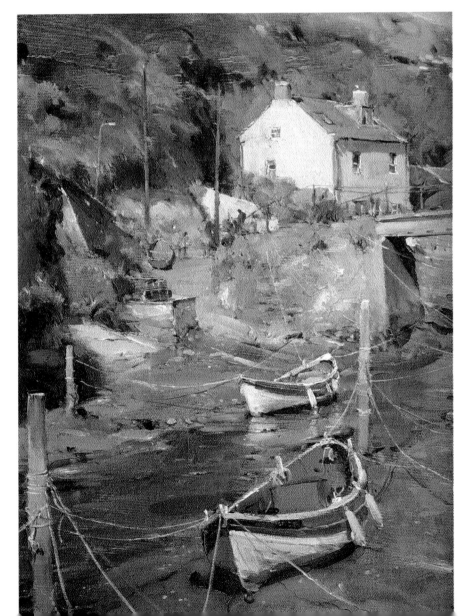

Low Water, Staithes Beck
Oil on board, 40.5 x 30.5 cm (16 x 12 in)
Invariably I find that a high viewpoint adds drama and impact to a scene.

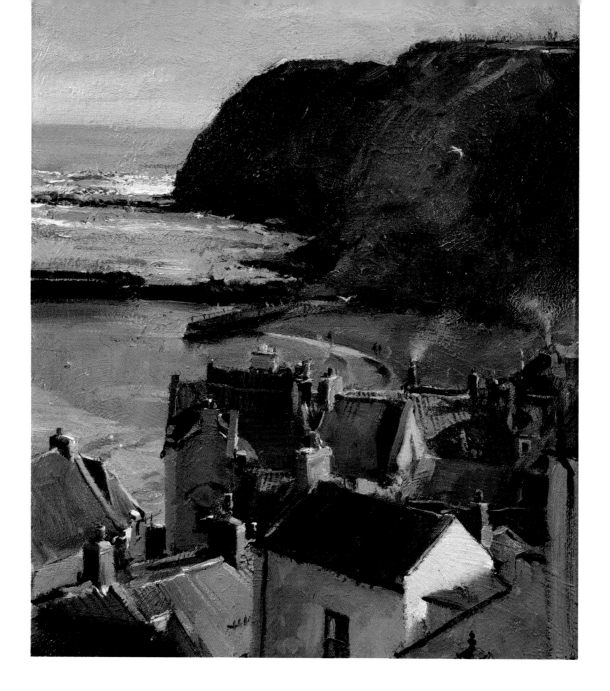

Equally, to create strong visual interest, the composition should involve some means of attracting attention and directing the viewer around the painting. Well-conceived directional lines are important here, as is a sense of rhythm in the way that the shapes and colours interrelate throughout the work. I also like to include little areas of mystery – passages that are unresolved and leave something to the imagination for the viewer to ponder.

I never rely on a set format, although instinctively many of my designs are based on the Golden Section proportion (an 'ideal' ratio originating in Classical art, in which the smaller part is in the same proportion to the larger part as the larger part is to the whole). Artists generally think of this in approximate terms as a one-third to two-thirds division of the picture surface. So quite often I am inclined to place a key feature or make an important division of the composition roughly one-third (or two-thirds) of the distance across the painting, either horizontally or vertically. For example, in *View from Cowbar, Staithes* (page 43), look at the position of the little bridge.

Cliffs and Rooftops
Oil on board, 30.5 x 25.5 cm (12 x 10 in)
Here again it is the viewpoint that counts – making the most of the different shapes and angles of the buildings.

Initial Marks

The amount of preparatory work undertaken before starting an oil painting is largely a matter of choice, and will no doubt be influenced by the degree of experience and confidence of the individual artist. Some artists like to make one or two exploratory composition sketches before working on the canvas. This is fine, I think, as long as the painting is not planned too precisely – the final work will be much more exciting and successful if there is freedom to make the most of interesting developments as they occur.

I occasionally make some sketches in the way described on page 43. Now, however, with the benefit of many years' experience, I usually start directly with a brush and some diluted paint, with strokes that indicate the basic structure of the subject. Outside, if I am standing up to paint, I hold the brush at arm's length, assessing the subject matter and drawing with a series of quick, stabbing strokes as I find my way around the composition. I use a fairly neutral colour, perhaps just a tone stronger than the preparatory ground colour on the board or canvas.

This drawing is kept to a minimum and eventually most, if not all, of these construction lines will disappear as more colour is added and the painting develops. Some subjects require more initial drawing than others, and in fact greater precision, as in *Steve's Jetty, Pin Mill* (below), for example. However, normally I keep the drawing loose, and for this I like to use an old, worn, flat-bristled brush, often a No. 2.

The process is much the same in the studio. The difference with studio work is that there is not the same sense of urgency, and consequently there can be a greater tendency to tighten up over the drawing. This has to be resisted – even if it has a more complex design, the painting must maintain that feeling of immediacy and spontaneity.

Steve's Jetty, Pin Mill
Oil on canvas, 51 x 61 cm (20 x 24 in)
I usually start with just a few brush lines on the board or canvas, but some subjects, like this one, need more precision in the initial drawing.

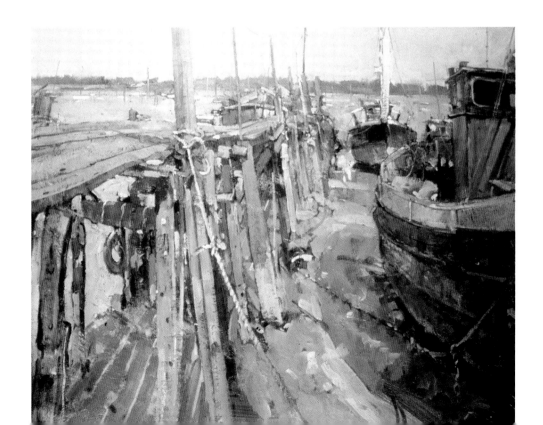

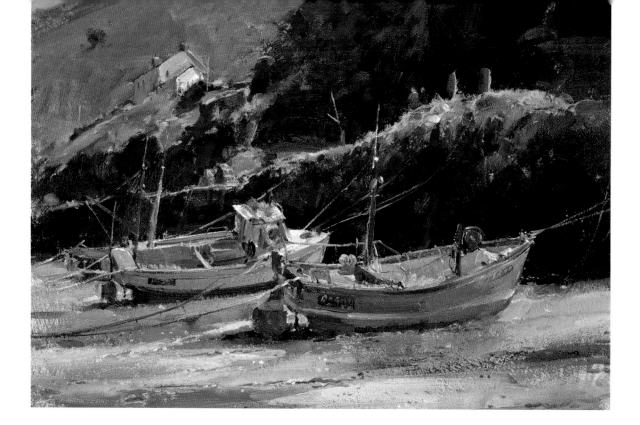

Sound Structure

The sketchy foundation lines provide an initial structure for the painting. An advantage of drawing with a brush and paint is that such marks are more easily assimilated into the subsequent work. Drawing with charcoal or a pencil, on the other hand, not only encourages a fussier approach, but also leaves marks that are much more difficult to 'lose' as the painting evolves. The drawing itself will essentially show the block shapes that I described on page 43 – a sort of skeleton composition over which I then loosely develop the basic tonal values.

Should this foundation need altering, the drawing can easily be removed with a turpsy rag. However, remember at this stage it is best not to make the drawing too precise. The exception might be when drawing shapes such as boats, which of course must look correct as far as scale, perspective and other aspects are concerned. But even here the shapes can often be refined later, making use of the negative surrounding spaces – as much as any actual drawing – to help resolve the shapes. In *Sheltered Moorings, Boscastle, Cornwall* (above) for example, it was far more effective to define the upper parts of each boat by cutting in with the dark colour behind, than by painting the boat shape itself.

Colour and Design

Another important aspect of design is the use of colour. Often it is the sense of colour as much as the quality of light that attracts me to a subject. The choice, relationships and placing of different colours – as well as the way that they impact on the composition – are therefore vital considerations. The harmony and contrasts, repeats and rhythms of colour are always key integrated forces within the composition, and they play a substantial part in influencing the viewer's response to a work. Look at the weight and distribution of colours in *Rocky Cove, Lleyn Peninsula, North Wales* (top right), for example, and compare this painting to *West Stockwith Basin, Nottinghamshire* (bottom right). Note how the colour, as much as any other factor, contributes to the way we 'read' and understand each painting.

Sheltered Moorings, Boscastle, Cornwall
Oil on board, 40.5 x 30.5 cm (16 x 12 in)
One of the advantages of oils is that you can define shapes by painting the 'negative' areas around them. This is how I perfected the outline of the boats in this painting.

Above: *Rocky Cove, Lleyn Peninsula, North Wales*
Oil on board, 20.5 x 30.5 cm (8 x 12 in)
A simple composition is often more dramatic and effective than one packed with detail.

Left: *West Stockwith Basin, Nottinghamshire*
Oil on board, 25.5 x 30.5 cm (10 x 12 in)
The choice and relationship of different colours within a composition can make all the difference to its interest and success.

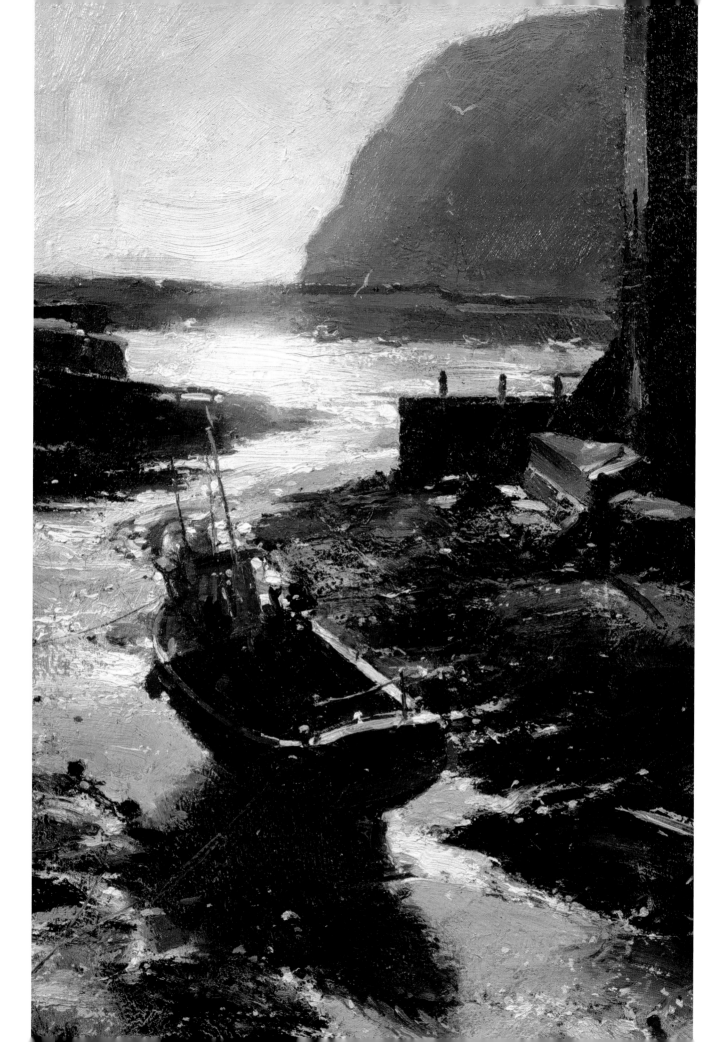

3 Capturing the moment

I paint outdoors whenever I can, but whether I am working *plein air* or in the studio, my aim is invariably to capture the sense of place and mood at a certain moment in time. Usually the element that most influences and defines the subject at a given moment – and which incidentally is also the most instrumental in attracting my attention – is the particular quality of light. Often, what is essentially quite a mundane-looking scene can be transformed by a *contre jour* (with the light directly behind the subject) or similar atmospheric lighting effect into something full of drama and interest.

Light adds the 'buzz' factor. Whatever the subject – and I paint quite a range of things, from portraits and lively beach scenes to quiet landscapes and vintage cars – I generally look for a powerful composition that is enhanced by an unusual effect of light.

Additionally, depending on the subject, I consider the potential to include figures, and I try to assess how the impact of the scene will alter as the sun moves across the sky and the light changes. Sometimes you have a gut feeling that in an hour or so the drama of light will be all the more intense, and consequently the subject itself will have added value. Imagination also plays a part. It is not always essential to depict everything as seen. I am not afraid to select or simplify aspects of the subject, or indeed introduce figures, if this will help create a more original, interesting result.

Morning Sun Rising, Staithes Beck
Oil on board, 30.5 x 20.5 cm (12 x 8 in)

Transient Effects

Light and weather are interrelated qualities: it is essentially the weather that determines the intensity and character of the light. Both are transient effects, although in certain parts of the world the weather conditions, and in consequence the light values, are more predictable than in other regions. Certainly when painting outdoors in the United Kingdom you have to accept that the exciting light effect that initially attracted you to a subject may not last, and that this can sometimes create practical difficulties.

The more you paint outside, the more experienced you become at judging the weather and deciding on the best approach. Although your first impressions of a scene may be very favourable, and you are full of enthusiasm to paint it, you may think the weather conditions are too changeable to allow an uninterrupted session of work. On the other hand, perhaps the weather is improving and there is every likelihood that the sun will come out and give you the benefit of a fabulous sky and light.

A High Point Above Dalehouse
Oil on canvas, 61 x 46 cm (12 x 16 in)
Light and atmosphere are all very well, but a touch of life makes an even more interesting subject. Here, I added the ponies from some sketchbook reference drawings.

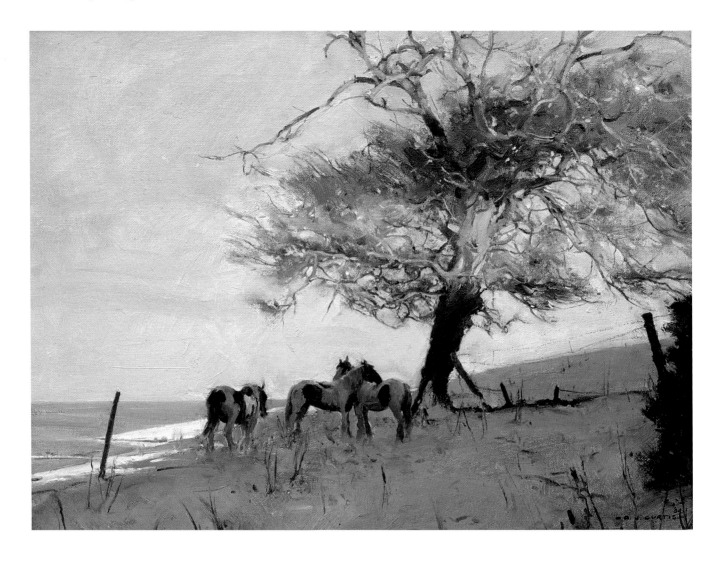

Similar judgements have to be made when painting harbour and coastal scenes. Will a rising tide kill the effect you want to achieve, or will it create some exciting reflections? Personally I prefer a falling tide, as in *Beachscape, Sandsend* (below) and *Rocky Foreshore and Bathers, Porth Ceiriad, North Wales* (page 60), because this leaves a wet, mirror-like surface with the light glancing over it, and I particularly enjoy the challenge of conveying those qualities.

It is always wise to work on painting the light effect straight away in a *plein-air* painting. Then, should the light change, you still have a reference for the effect you wish to express. An alternative approach is to start with a tonal sketch, as described on page 66. If subtle changes and nuances of light subsequently

Beachscape, Sandsend
Oil on canvas, 61 x 76 cm (24 x 30 in)
Beach scenes with wet sand and the light glancing over it are subjects that I find especially interesting and enjoyable to paint.

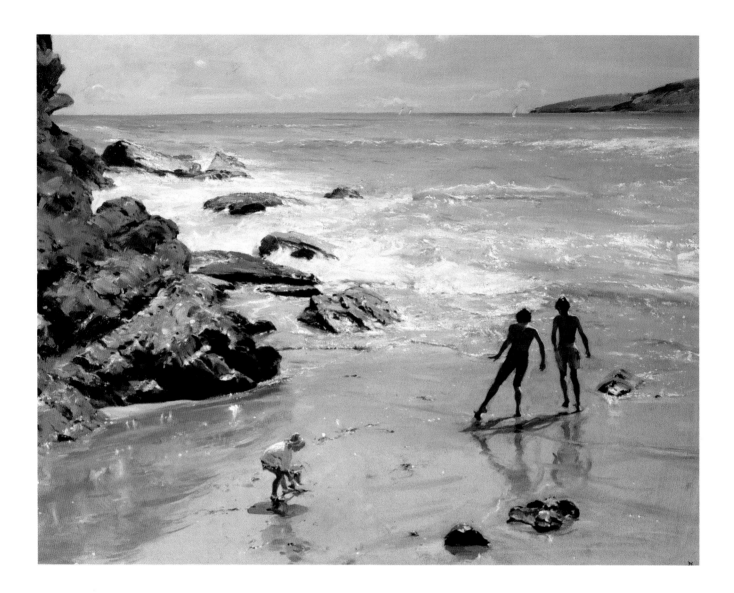

develop that add to the impact of the scene, these can usually be incorporated. Conversely, if there is a temporary loss of light, this can also be an advantage, because it will enable you to see more variety of tones in the darks.

Should the weather change so completely that the light and mood you intended to express are entirely lost, then you are left with two options: either abandon work for the day, and perhaps hope to finish the painting in the studio; or start another painting. The worst light is what I would describe as 'dead' light, by which I mean the sort of murky light in which there is no sense of recession. By contrast, when it is cloudy and there is a flat, even light, there will be depth and subtlety, which are qualities worth exploring. The great advantage of flat light is that it offers more time to produce the effects that interest you.

I paint outside throughout the seasons, and I also enjoy painting further south in Europe, where the quality of light, and the colour, can be far more intense. There are often magical contrasts to exploit, for example when you come across white buildings set against an azure blue sky or sea. However, one of my favourite types of subject is the winter landscape. There is immense subtlety in the winter light and colour, which I find all the more satisfying. Perhaps what is best about the unpredictable nature of light is that it creates a certain amount of tension. There is some risk and challenge, and usually this translates into more sensitive and dynamic work.

Rocky Foreshore and Bathers,
Porth Ceiriad, North Wales
Oil on canvas, 61 x 76 cm (24 x 30 in)
Again, it is elements such as light, reflection and shadow that make all the difference to a scene such as this.

Moments in Time

Success in evoking the special qualities that define a scene, and in capturing the feeling of being there at a certain moment in time, depends principally on two factors: your visual and emotional response to the subject matter, and how adept you are with the medium. The sensitive, appropriate use of colour, the techniques chosen, and the way that paint is applied to convey the subtleties of light and other atmospheric effects, are essential skills to master.

Glazing is an especially good technique for suggesting different qualities of light, although blending, impasto and other brushwork effects can also be useful, depending on the character and texture of the surface or the light effect being represented. You can see that I have used a variety of these techniques in *Head of the Loch, Kentallen, Argyll* (below).

Head of the Loch, Kentallen, Argyll
Oil on board, 61 x 46 cm (12 x 16 in)
You may need to use a variety of brushwork effects and painting techniques to capture a particular type of mood and light, as here.

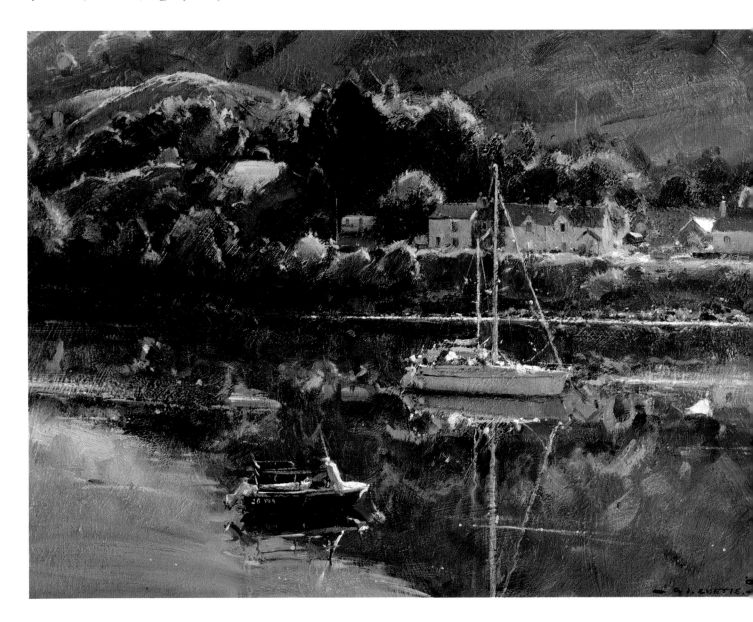

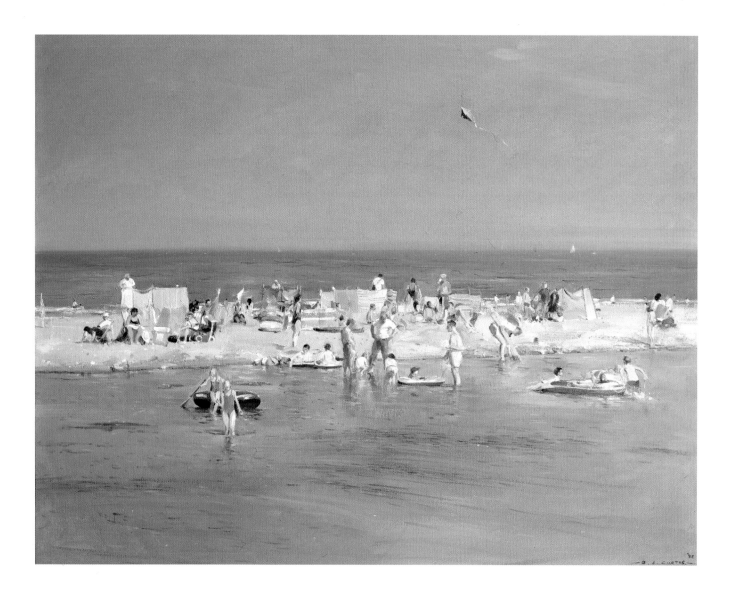

This painting also demonstrates the point that when you have knowledge of a particular subject, you can choose the best time of the day to capitalize on the lighting effect you want to achieve. I was aware of this wonderfully atmospheric scene for several days before I went back to paint it. The location is in the Scottish Highlands, and at the time we were staying in a rented house nearby. One morning, when I was out walking at about 7 am, I caught sight of this subject and was immediately struck by its stunning composition and the emerging quality of light. I knew that when I returned to produce a painting it would have to be at the same time of day, because after a while the light changed completely and the scene eventually became a rather typical, almost chocolate-box type of landscape view.

I chose a board ready-primed with a darkish ground that would suit the general tonality of the subject and help me pitch the extreme lights and darks. In fact, I deliberately arrived at the spot early so that I could block in the main areas and establish the underpainting before the dramatic light effect began to emerge. Then, when the halo effect of the trees began to show, along with the glints of light on the boats and distant buildings, I was able to concentrate on these for the thirty or forty minutes that they lasted. *Plein-air* paintings like this are an absolute joy. There is no way that I could have experienced the same delight if I had painted the subject in the studio from photographs.

The Sandbar, Sandsend
Oil on canvas, 61 x 76 cm (24 x 30 in)
This was one of those occasions when it was well worth the time spent looking for the best viewpoint and composition. By focusing on this particular section of the beach it seemed to take the subject into a degree of abstraction, and so generate an unusual quality of composition.

Light and Shade

As *Wave Forms and Breakers* (above) illustrates, it is usually a certain quality of light that adds the magic or 'buzz' to a scene, and more often than not this is the factor that initially attracts me to a subject. For the *plein-air* painter there is tremendous scope to explore different light effects, which can vary enormously depending on the season, the weather, the time of day, and so on. I like to work in all types of light but, being a tonal painter, I am generally happiest when I can paint *contre jour* (facing towards the light) or when there is a half-light with the sun just breaking through the clouds.

In a *contre-jour* subject, because you are looking into the light, and hence the main forms are backlit, shapes are simplified and mostly seen in silhouette or partial silhouette. For me, part of the appeal of this type of light is that the truly dark areas have a certain mystery. It is not possible to define to any extent what goes on in these areas, but you have to suggest just enough to keep the painting lively and, in turn, keep the viewer interested. Look at the darks in *A Bold Walk*

Wave Forms and Breakers
Oil on canvas, 61 x 76 cm (24 x 30 in)
So often it is a special kind of light that adds the magic to a scene and, as happened here, this is the quality that usually attracts me to the subject.

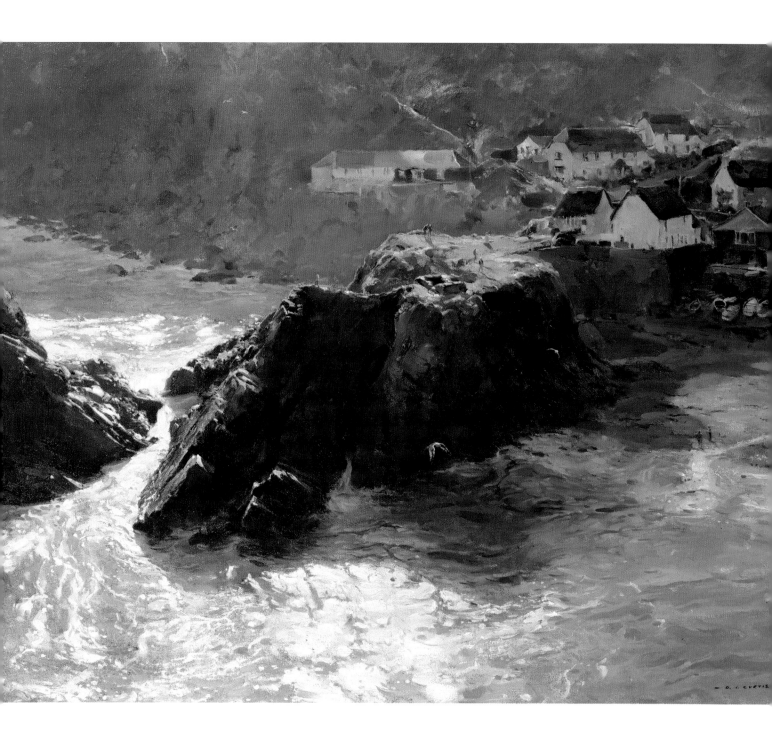

Across the Todden, Cadgwith (above), for example. What is also appealing about *contre jour* is the way that bold, dark shapes contrast with little nuances of bright light and detail here and there.

A Bold Walk Across the Todden, Cadgwith
Oil on canvas, 61 x 76 cm (24 x 30 in)
In a *contre-jour* subject, I like the way that bold dark shapes can contrast with little patches of bright light.

Tonal Values

Whatever the light effect, it is advisable to start by setting the tonal range for the painting. This will involve looking at the very lightest and darkest areas and deciding on the exact strength of tone that these should be. In a *contre-jour* subject it is important to ensure that the darks are sufficiently dark for the lights to have an impact. As in *A Bold Walk across the Todden, Cadgwith* (left), the lights should resound against the darks; there should be some drama and tonal contrast. This may need exaggerating in the painting, although usually I prefer to be as true to the subject as possible.

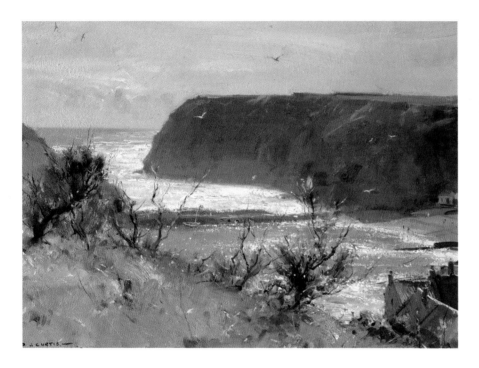

View from the Nab
Oil on board, 25.5 x 35.5 cm (10 x 14 in)
Here, the foreground was the key element in making the composition work. The contrasting warmth of the colour in the foreground enhanced the sense of space and distance, while the gorse bushes provided a necessary linking feature.

Milking Time at Strawsons
Oil on canvas, 30.5 x 51 cm (12 x 20 in)
From my studio window I regularly enjoy watching the cattle coming in for milking. In the winter they walk by and cast wonderfully subtle blue shadows, and I have often felt that this scene would make a very interesting and successful painting.

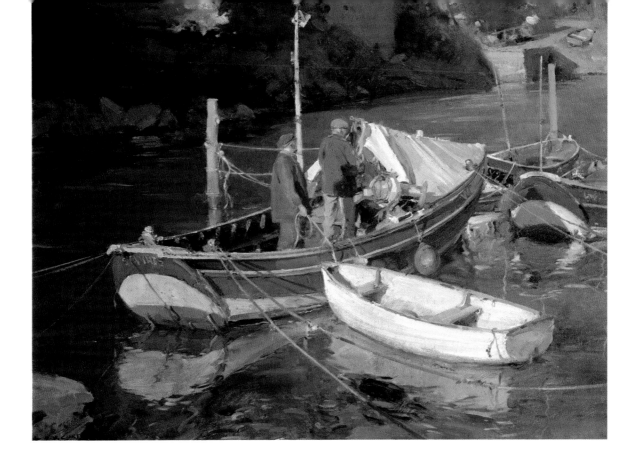

Approaching High Water, Staithes Beck
Oil on canvas, 40.5 x 51 cm (16 x 20 in)
This is an example of a studio oil painting for
which I used an earlier *plein-air* line-and-wash
watercolour as the inspiration and reference.

Having made a judgement about the tonal 'weight', I am able to decide about
the board or canvas I want to use, and what sort of initial ground colour and tone
it should be. Usually I like it to be a mid tone, and I begin by blocking in the
extreme darks (by painting) and lights (by rubbing out) on it, to establish the
tonal range that I am going to use for the painting.

In *A Bold Walk across the Todden, Cadgwith* (page 64) I used a mix of French
ultramarine, cobalt blue and raw sienna for the initial overall wash, which was
consequently slightly darker than a mid tone. I worked almost directly into this
to place the darks and, with a rag, I rubbed out the extreme lights. Also with the
rag, although applying less pressure, I roughly picked out some of the buildings,
and I used my thumbnail with the rag to tease out the bright touches of light on
the rocks. Thus, in just a few minutes I had created a sense of the general layout
and tonal values for the painting – and by so doing had also, incidentally, built up
a good level of confidence to tackle the next stage.

Of course, it is more difficult to set the tonal range when working from
photographs and other resource material in the studio. In fact, photographs are
seldom very helpful in this respect. A quick tonal sketch made on site is far more
useful. This need not be very elaborate – just blocks of light, medium and dark
tones to remind you of the general tonal distribution. The sketches can be made
in soft pencil, charcoal or perhaps directly in oils, as I sometimes do. I take a
small piece of board and simply indicate the main tones using a few concertina-
style brushstrokes, as described on page 38.

Another alternative in the studio is to use a finished *plein-air* painting as the
reference, and work on a new painting in a different medium. For example, I
painted *Approaching High Water, Staithes Beck* (above) from a line-and-wash
watercolour that I had previously made on location and, conversely, *Head of the
Loch, Kentallen, Argyll* (page 61) was painted in oils first and a version in
watercolour later.

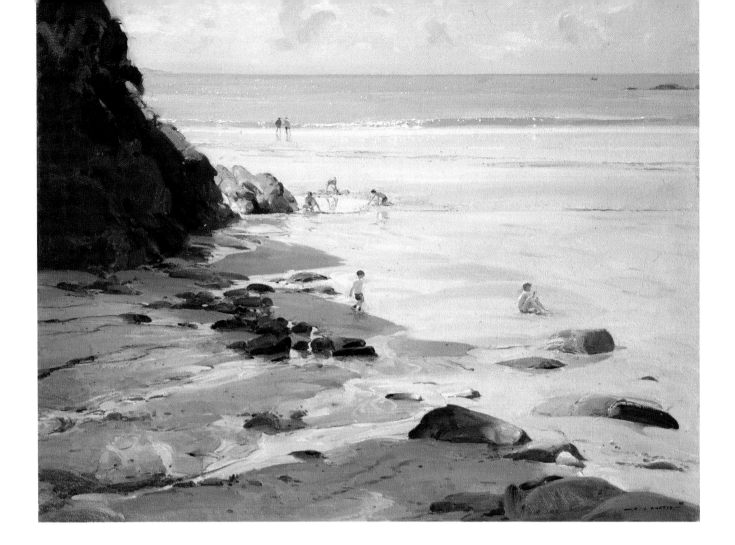

Interesting Shadows

A technique that many artists use to help assess the lights and darks in a scene is to look at it through half-closed eyes. This simplifies and enhances the tonal effect, so that you can readily identify highlights, shadows and mid tones. Often, the shadows themselves play a vital part in the design and impact of a painting, and they are also an important feature in suggesting a certain quality of light and a particular mood.

My advice is not to rely on photographs for information about shadows because I have found that these tend not to show any of the subtleties and interest that the eye can see in the dark areas of a subject. Make sketches and notes where appropriate and, if you are painting *plein air*, use those moments when the sun disappears behind a cloud to observe, understand and express the variations of form and texture within shadows. Also, in a low light, the way that shadows link different parts of a composition and create rhythm and patterns will be more noticeable.

However, in general shadows are more convincing if they are not too defined or too insistent in tone and colour. They are rarely black, of course, and in fact seldom one colour all over. Look for variations of colour, and relate the shadow colour to that of the parent object. Mostly, they are a bluer version of the underlying surface colour. This is demonstrated in *A Family Group, Porthcothan, Cornwall* (above), where the expanse of foreground shadow has a slightly blue quality, but remains transparent, so that the yellowness of the sand shows through. Note too how this shadow area is an effective compositional device.

A Family Group, Porthcothan, Cornwall
Oil on canvas, 61 x 76 cm (24 x 30 in)
Shadows not only add contrast and interest, they can also be a useful compositional device, as here.

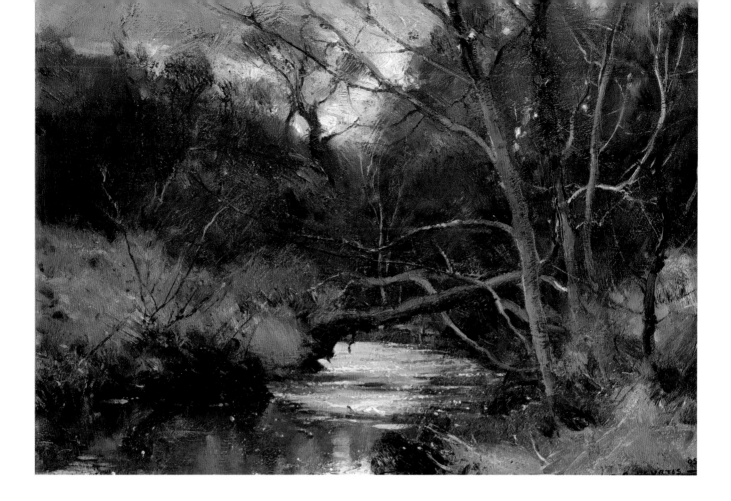

Interpretation

If, like me, your main interest is in *plein-air* work, then naturally most paintings will start with observation. However, working directly from the subject does not necessarily mean that you have to make an accurate, lifelike depiction of what is there. Of course, you may well want your painting to look like the subject or be readily identifiable with a certain place, but at the same time it ought to reveal something about you, the artist. Something that is always important is your personal response to the subject matter, and this is usually evident in the way that certain qualities are emphasized in the painting.

Most likely those qualities will be the ones that first attracted you to the subject, and most excited and inspired you. Sometimes this 'buzz' factor comes from a particularly interesting composition, as I found in *Midwinter up the Beck* (above). Or it could be a striking quality of light or atmosphere, as in *Autumn Landscape near Brockweir, the Wye Valley* (top right); a lively sense of colour, as in *Windswept Pines, Dunstaffnage Castle, Scotland* (bottom right), or some other feature that evokes a strong reaction. But whether the appeal is something about the content, mood or colour, that will be the quality I will most want to search out in the painting. It will be the focus of my interpretation.

Obviously another aspect of interpretation is painting technique or style. This is something that evolves with experience, so that one artist can produce marks that are full of sensitivity and expression while those of a less-able painter will be dull and unmoving. As explained later in this section (see page 72), to successfully capture the effect of a particular moment in time, the choice of technique is crucial. Again, with an experienced artist the brushmarks will show confidence and personality as well as conjuring up a certain feeling or effect.

Midwinter up the Beck
Oil on board, 23 x 30.5 cm (9 x 12 in)
This has the sort of light effect that I associate with some of the Victorian painters. It is a subject that could result in a rather twee painting, but I very consciously tried not to let it develop that way.

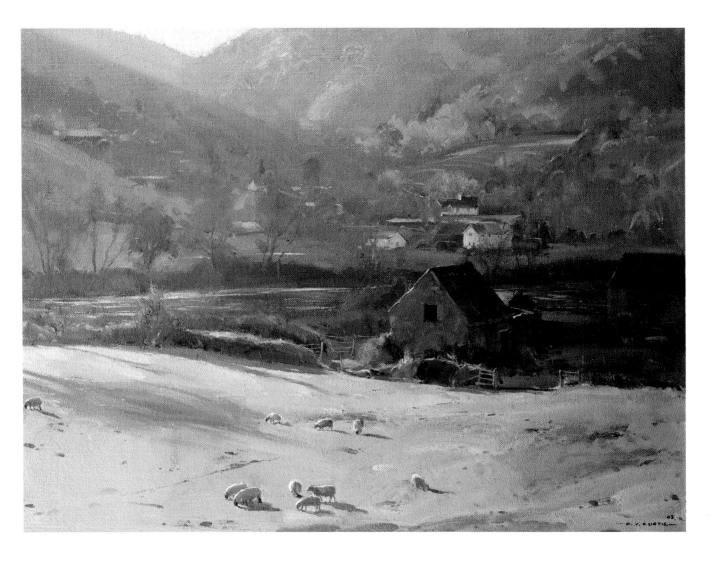

Above: *Autumn Landscape near Brockweir, the Wye Valley*
Oil on canvas, 46 x 61 cm (18 x 24 in)
There was a lot of damp in the air on this particular day, and the valley was shrouded in a veil of mist. This subdued the greens and, although still fairly high key, created the sort of colour range that I find most appealing.

Left: *Windswept Pines, Dunstaffnage Castle, Scotland*
Oil on canvas, 61 x 76 cm (24 x 30 in)
Colour was also the principal attraction in this subject.

Colour Key

The choice and use of colour is also an extremely important factor in achieving a convincing sense of mood and place. If the colours are not subtle enough, for example, or they are applied in an insensitive way, then the finished painting will fail to convey the feeling you had in mind. So the first thing to consider about colour is the colour key – essentially whether the subject is best interpreted with strong, warm colours or cool, subdued ones – and, following from that decision, the exact palette of colours to work with.

The way we react to colour and interpret it is something that can vary considerably from one person to the next. I confess to not being very daring with colour, and in fact, rather than enhance the colour in a scene as some artists would, I tend to subdue it, particularly when dealing with mid-summer greens in a landscape subject. Some variety and contrast is essential in every painting, of course, otherwise it will seem very even-toned and unexciting. But principally it is the tonal qualities of a subject that interest me, and I would describe myself as a tonalist rather than a colourist.

For me, the colour in *A View from The Mall* (below) is quite high key. Although it is in central London, I felt this subject had something of a Mediterranean quality about it, with the white buildings set against an azure sky. But even here you will notice that I had a slight reticence in exploiting the

A View from The Mall
Oil on board, 20.5 x 30.5 cm (8 x 12 in)
I liked the striking contrasts of colour here, with the chalky white buildings set against an azure sky.

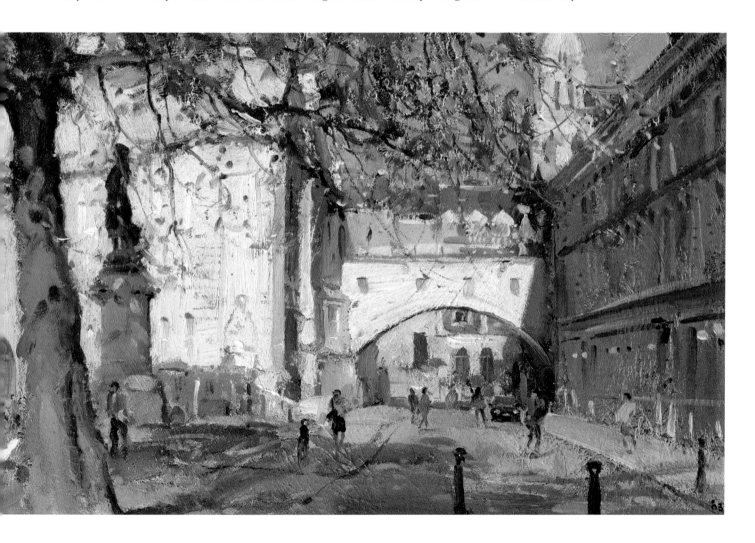

63

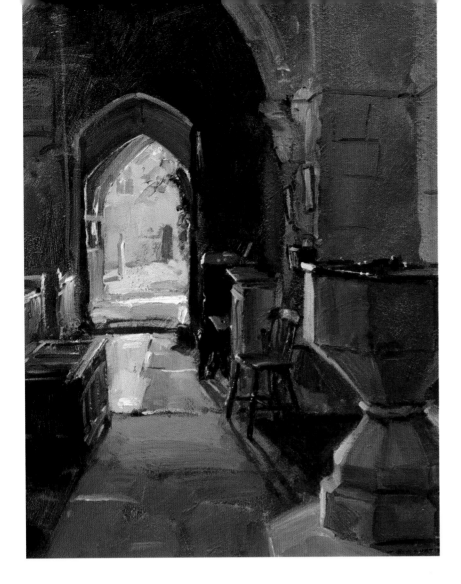

Parish Church Interior
Oil on board, 40.5 x 30.5 cm (16 x 12 in)
To ensure the control and harmony of colours it is best to keep to a limited palette. My palette for this painting consisted of just seven colours.

colour – perhaps I could have made the red figures in the foreground more prominent, for example. Generally my approach is to respect the colour as seen, and I aim for a result that has both harmony and interest. See also *Windswept Pines, Dunstaffnage Castle, Scotland* (page 69).

I especially like the subtle colours of later autumn and winter. *Autumn Landscape near Brockweir, the Wye Valley* (page 69) was a very atmospheric scene that I came across one November afternoon. Again, I regard this as a mid- to high-key subject, and what particularly interested me was the challenge of the light effect, and how to suggest the veil of mist hanging across the valley. For this sort of effect I rely on shifts, variations and subtle blends of colour as I work across the area and observe the diffused forms. It is comparable to the way I would apply a variegated wash in watercolour. The mixes start with French ultramarine and raw sienna, and then progressively include white, buff titanium, cobalt violet and other gentle colours.

I always use a limited palette, probably no more than about eight colours (see page 22), choosing these to suit the nature of the subject matter and the effects I have in mind for the painting. There are a lot of advantages, I think, in keeping things simple, and a limited palette helps tremendously with the control and harmony of colours. My palette for *Parish Church Interior* (above), for example, was limited to titanium white, French ultramarine, cerulean blue, lemon yellow, raw sienna, buff titanium and viridian hue.

Appropriate Techniques

A knowledge and experience of a wide range of oil-painting techniques is certainly an advantage, as obviously this enables you to be confident in selecting and using the most suitable methods for interpreting the chosen subject matter. Each painting adds to this experience, though equally every painting is a new challenge and will inevitably require something slightly different in terms of the techniques used.

The viscous character of oil paint means that brushmarks will remain as stated, rather than fuse together and even out as they might in watercolour. Thus, in addition to glazing, blending and the various other techniques described earlier (see pages 31–39), the quality of the brushmarks is something to exploit, and this is often the most important means of describing and suggesting different objects and effects in a painting.

Another interesting point about technique is that the success of a painting is very much influenced by factors such as confidence, enthusiasm and how you feel on the day. As I have said before, if you are feeling inspired and optimistic about an idea, you are more likely to paint with vigour and confidence, and this will be reflected in the brushwork. The painting itself will look lively, spontaneous and interesting, which is so important. *A Sandbeck Corner* (above) demonstrates these points. The brushstrokes for the foliage show that sort of confidence. They are not fussy – you can tell exactly how the brush was laid on and swept off the board surface – yet they imply a great deal.

The technique is also carried by enthusiasm in *Engine Shed, Grosmont* (top right). Old machines, including locomotives, are favourite subjects of mine, and on this particular day I had the rare opportunity to paint in a railway workshop. I did three paintings on site that day, and what I especially like about *Engine Shed, Grosmont* is the sense of mystery – just enough is suggested, but quite a lot is left to the imagination. In contrast, *Moorings Along the Seine* (bottom right) is a studio painting involving quite a variety of sub-techniques.

A Sandbeck Corner
Oil on board, 20.5 x 30.5 cm (8 x 12 in)
Confident, unfussy brushmarks are important in creating a lively, interesting result.

Top right: *Engine Shed, Grosmont*
Oil on board, 28 x 42 cm (11 x 16½ in)
As in the dark areas here, I think paintings should always include passages where there is a sense of mystery and the detail is left to the viewer's imagination.

Bottom right: *Moorings Along the Seine*
Oil on canvas, 46 x 61 cm (18 x 24 in)
In studio paintings such as this, the work can be more resolved and may therefore require a much wider range of techniques.

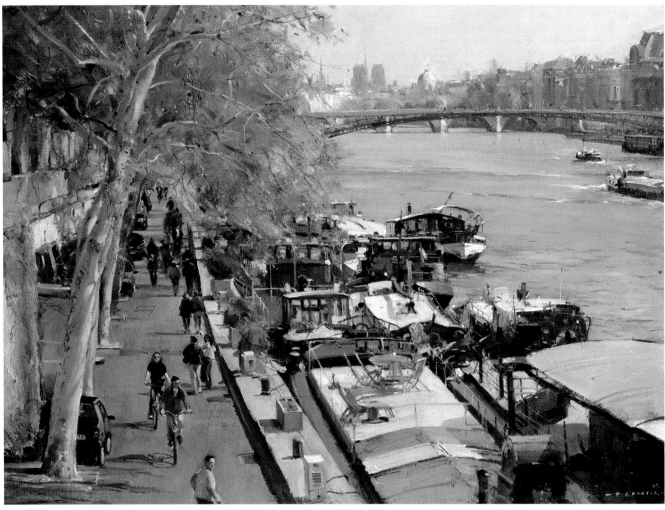

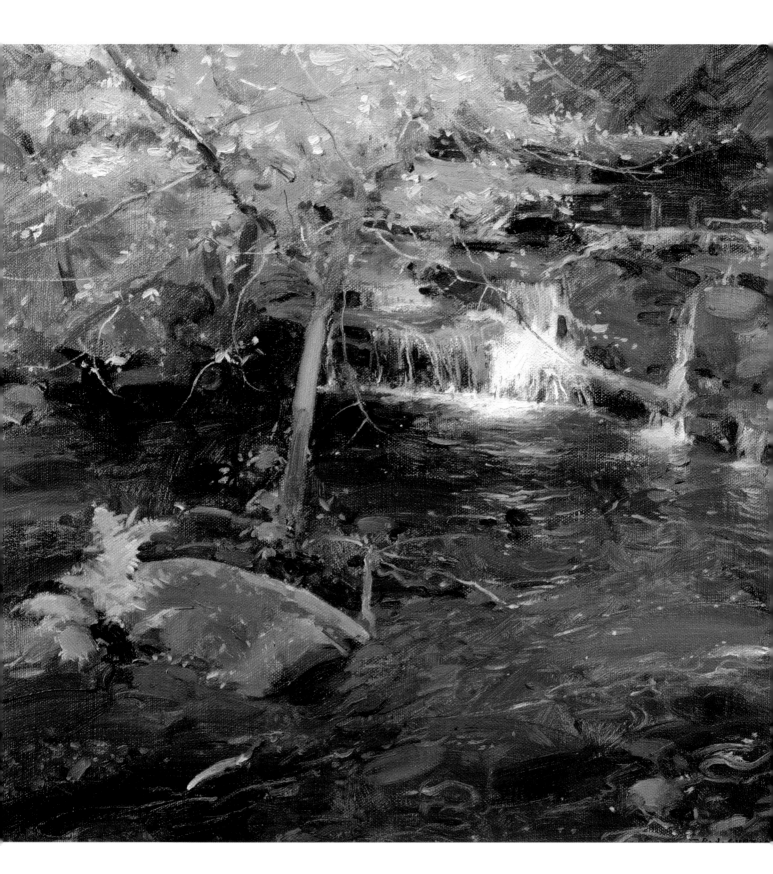

4 Choosing subjects

I like variety in subject matter and, for me, oil paint is the perfect medium to use. There are some subjects that I would much rather tackle in oils than, say, in watercolours, such as fleeting light effects. I find I have more control and speed in oils. Watercolour relies on gravity, and therefore your brushstrokes risk losing definition if the paint is too fluid. But in oils the brushstrokes remain as stated and the paint adheres and responds in a much more reliable way. Also, while in water-based paints the colours tend to dry lighter, in oils – as long as you do not reduce the oil content too much – the colours stay the same.

For these reasons I feel more confident with oils, and they particularly suit my love of *plein-air* painting. The many different subjects I paint include coastal and harbour scenes, landscapes, interiors, buildings and people. I especially like subjects that enable me to focus on a small area. I enjoy the discipline of selecting a tiny, interesting section from a large expanse of landscape or coastal scenery, as in *Waterfall in the Rivelin Valley, Derbyshire* (left). And, in contrast, another favourite subject is the high-viewpoint, high-horizon scene, where I am looking down on a landscape, beach or townscape.

Waterfall in the Rivelin Valley, Derbyshire
Oil on canvas, 40.5 x 40.5 cm (16 x 16 in)

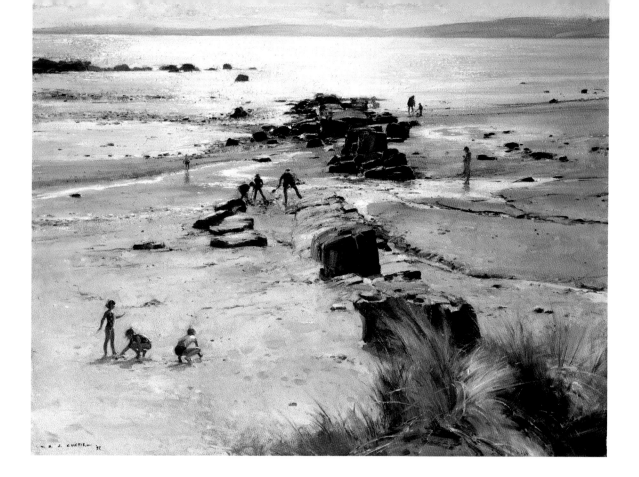

Features of Interest

The first consideration in any subject matter is the composition; I am looking for a design in which there is an interesting, perhaps unusual relationship of bold shapes that will be both challenging to paint and create a visually exciting result. When I start to observe the various elements of the design more closely I will usually want to simplify what is there, but at the same time I am thinking about the weight of interest within each part, and how this will relate to the whole and contribute to the overall balance and contrast in the painting. For instance, skies and foregrounds are areas that need particularly careful assessment in this respect.

The sky is always important because it sets a tonal reference for the work. Equally, it acts as a foil, an interesting backdrop for the rest of the painting. Often, in a subtle way, it also helps with the sense of rhythm and movement around the composition. Because I like viewpoints that are close-up or from above, the sky area is relatively confined in many of my paintings, as for example in *A West Coast Beach, Scotland* (above). Nevertheless, even if it is just a narrow band across the top of the painting, it will still play its part in influencing the mood of the picture and the suggestion of space. So it must look convincing.

I have used a more extensive and dramatic sky effect in *Old Olive Groves, Pollensa, Mallorca* (top right) and also in *Winter Landscape, Everton, Nottinghamshire* (bottom right). In both examples I have modified what I actually saw in the way of cloud formations and colour to echo features in other parts of the composition and consequently strengthen the sense of flow and design within the work. The bank of blue above the roof in *Old Olive Groves, Pollensa, Mallorca* for instance, directs the eye over the tree forms and initiates a movement around the painting to the focal point: the goat in the foreground.

A West Coast Beach, Scotland
Oil on canvas, 61 x 76 cm (24 x 30 in)
Even a relatively small amount of sky will play its part in influencing the mood of the painting.

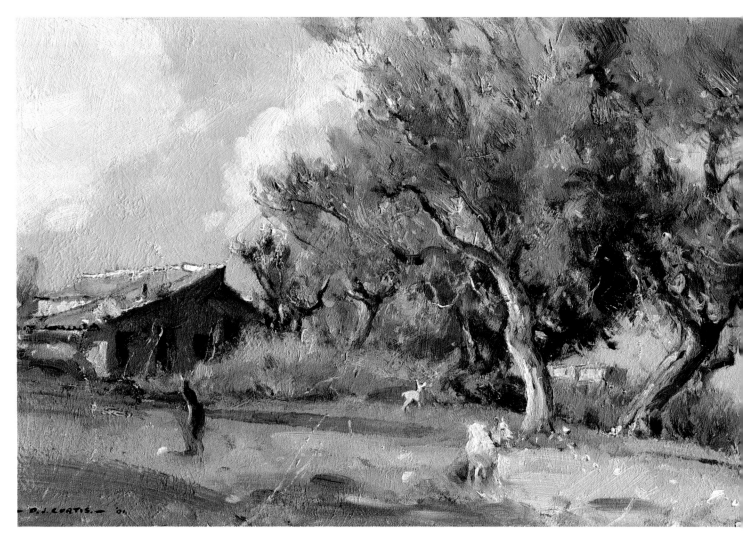

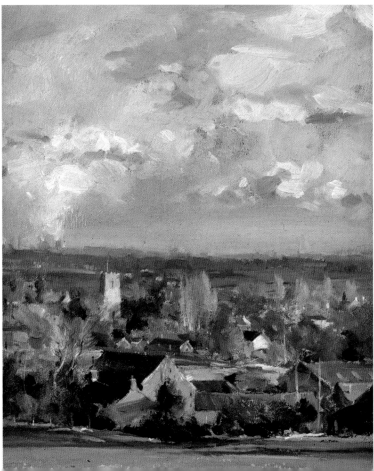

Above: *Old Olive Groves, Pollensa, Mallorca*
Oil on board, 20.5 x 30.5 cm (8 x 12 in)
In a more dramatic sky, colour and cloud formations will contribute to the overall effectiveness of the composition.

Left: *Winter Landscape, Everton, Nottinghamshire*
Oil on board, 30.5 x 25.5 cm (12 x 10 in)
Here, the sky area is in complete harmony with the rest of the painting.

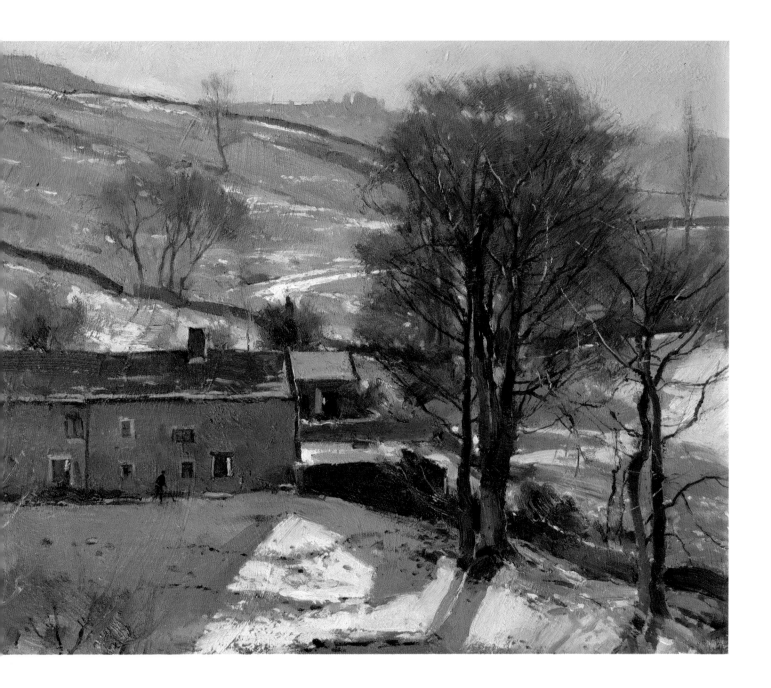

A certain amount of foreground interest is necessary in every painting. I prefer not to make the foreground too active, but I do like it to include something that will draw the viewer's attention into the painting and, perhaps like the sky, create a foil for the middle-distance, where most of the action is usually concentrated. When a foreground is lacking interest I sometimes introduce a figure or two, but if it is weak and I am unable to invent something, then I will probably look for another subject to paint.

While an empty foreground is unexciting and unhelpful, so too at the other extreme is a cluttered or overworked one. It does not take much to make the foreground interesting and successful. In *A West Coast Beach, Scotland* (page 76), for example, it is just a few tussocks of grass that lead the eye into the painting. Similarly, as in *Late Snow above Hathersage, Peak District* (above), shadows will break up a foreground area and create useful lead-in shapes. In general I avoid big empty spaces anywhere in a painting. I prefer simple areas that are punctuated with features of interest.

Late Snow above Hathersage, Peak District

Oil on board, 25.5 x 30.5 cm (10 x 12 in)
Shadows can provide very helpful lead-in lines and compositional shapes, as in the foreground area of this subject.

Focal Point

I think of the focal point or centre of interest as the part of the composition that most attracts the viewer's attention; the place where the eye comes to rest. It is often a figure or some other aspect of the subject matter, but it can be something more abstract, such as a dominant colour or shape, or perhaps a strong light or colour effect. As in *A West Coast Beach, Scotland* (page 76), I try not to make the focal point too obvious. Here, the small group of figures just off centre is the focal point, but this links with figures in other areas of the painting, and together they create pulses of interest throughout the picture area.

Essentially, each painting is built around a focal point, and the selection of this point is something that I instinctively make a judgement about when I choose the subject in the first place. I use my hands as a viewfinder, as described on pages 47–48, and having determined where the centre of interest will be, I look at the various composition alternatives to assess which will make the most effective painting. In *Late Winter Snow above Dalehouse, Cleveland* (below) I focused on the farmhouse in the middle-distance and decided that the best composition would be portrait-shaped, using the foreground fence posts as a bold, directional lead-in to the painting.

Late Winter Snow above Dalehouse, Cleveland
Oil on canvas, 68.5 x 51 cm (27 x 20 in)
The distant farmhouse is the focal point in this composition, and I have used the hedgerows and foreground fence posts to direct the eye around the painting.

Scale and Detail

When working *plein air*, decisions about the size and format of the painting are made as part of the initial assessment of the subject matter, and will naturally relate to the type of composition and my general intentions for the work. In the studio, similar considerations apply, but because there are no actual time constraints, and there is greater control over the way ideas are formulated, large-scale work is possible, and you can be more ambitious with the content. However, the two main factors in determining the scale and format are the subject matter itself – whether it works best as a small painting or a large one – and your degree of confidence.

Pond and Bulrushes, Tickhill, Yorkshire
Oil on canvas board, 61 x 51 cm (24 x 20 in)
Here I have again made the most of the foreground interest as a compositional device.

Paintings are more likely to be successful on a small scale, because by necessity they need to be simple and concentrate on the essential shapes and qualities in the subject. But having started outside on a small board or canvas, you may discover that the idea has the potential to work as a larger, more resolved studio painting. This is an approach that I often use – exploring the possibilities of an idea on site and testing my confidence with it, and then using this as the reference for a more ambitious work later on.

When painting outside, factors such as changing light, the limited amount of time available and technical considerations obviously influence the choice of subject matter, the stylistic freedom and the size of work. When outside, I rarely work on a scale larger than 30.5 x 40.5 cm (12 x 16 in). Sometimes it is possible to return to a location the next day and continue with the painting, particularly when painting in southern Europe where the weather is likely to be more predictable, but usually a *plein-air* work has to be finished in a single session of perhaps no more than two or three hours. Painting on site is intensive work, even when using small boards or canvases. The sizes I use are 15 x 20.5 cm (6 x 8 in), 20.5 x 30.5 cm (8 x 12 in), 23 x 30.5 cm (9 x 12 in), 25.5 x 30.5 cm (10 x 12 in), 25.5 x 35.5 cm (10 x 14 in) and 30.5 x 40.5 cm (12 x 16 in).

As for shape, sometimes a landscape has far more interest and impact if it is painted as a square or vertical format rather than the traditional horizontal shape. The scene in *Winter Landscape, Everton, Nottinghamshire* (page 77) looked fairly ordinary when viewed as a traditional landscape shape, though much more exciting the other way round. In contrast, a subject such as that shown in *The Blue Tractor, Sandsend* (above) could only work with the horizontal format.

The Blue Tractor, Sandsend
Oil on board, 40.5 x 51 cm (16 x 20 in)
The size and shape of a painting are always important factors to consider in relation to the subject matter. For example, this scene could only work with a horizontal, rectangular format, as here.

How Much Detail?

I dislike fussy paintings. All my paintings are a simplified version of the subject matter. I might increase tonal values if I feel this is necessary to add drama to the light effect, but I never increase detail. In my view, every painting should include passages where the eye is allowed to rest – areas of mystery where the viewer is left to decide exactly what is happening. These areas are just as important as the more descriptive ones. Busy paintings, full of detail, are never as interesting as those in which we are allowed to use our imagination.

Where there is a lot of detail in a subject it can be tempting to get involved with it and consequently overstate the effect. The way to avoid this is to discipline yourself not to spend more than about five minutes painting any one area. Try to keep the whole painting developing at the same pace and therefore, instead of finishing one part and moving on to the next, chop and change the colours, techniques and areas of the painting that you are working on. Suggest detailed surfaces such as tiled roofs or brick walls by indicating the effect here and there, rather than painting every tile or brick. As you paint, keep in mind the need for harmony and unity throughout the entire painting, and avoid too much hard-edged work.

Entry to the Beck
Oil on board, 25.5 x 30.5 cm (10 x 12 in)
What I liked in this subject was the contrast of light and dark with the patchwork of warm and cool shapes.

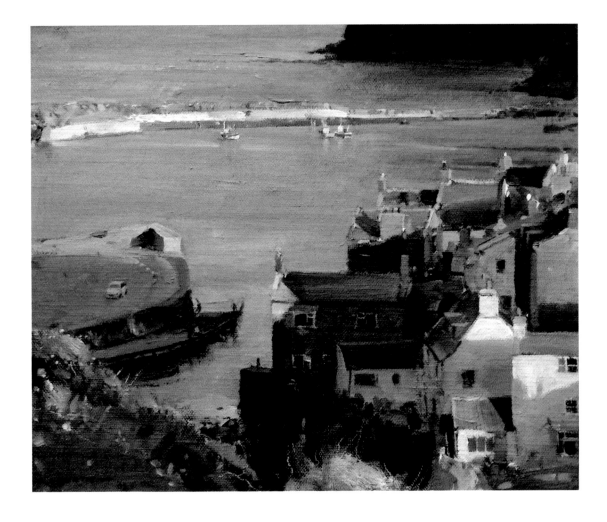

Above: *Winter Tree Forms, Wadworth*
Oil on board, 20.5 x 30.5 cm (8 x 12 in)
The motivation here was the quality of the
tree forms and the way they interact.

Left: *Evening Diners, San Gimignano –
Tuscany*
Pencil sketch, 15 x 20.5 cm (6 x 8 in)
This sort of reference drawing is very useful
for studio paintings.

Reference Material

Making a sketch is an excellent way of familiarizing yourself with the subject, exploring its potential and gaining some confidence before starting an oil painting. Especially when contemplating a studio-based painting, one or two on-site sketches will provide a wealth of information, as well as create a link between reality and the inevitably detached nature of the work when completed indoors. Photographs are also useful (see page 45), but as discussed earlier it is wise not to rely exclusively on them.

There are plenty of different sketching materials to use, so my advice is to experiment and find those that you feel most comfortable with. Soft graphite pencils, pen and ink, charcoal, sketching pens, water-soluble pencils and pastels are all interesting materials to try. Also, watercolour is a particularly good medium for sketching, and I would recommend a compact watercolour set containing a few essential colours such as cobalt green, French ultramarine, cerulean, cobalt violet, raw sienna, burnt sienna, permanent rose and Indian yellow. A quick watercolour sketch, made in a small, 15 x 20 cm (6 x 8 in) sketchbook, will tell you immediately whether or not the subject will work on a bigger scale in oils.

At the beginning of my career I was fortunate to have a first-rate tutor who taught me to draw and encouraged me to try various media. I once spent a whole year working in pastel, for example, and I remember how I used to love using a pump-action Flowmaster pen that, with experience, gave a wonderful range of tonal effects. Now, I mostly sketch with a soft pencil, usually a 3B or 4B. This will produce a variety of marks and enable me quickly to establish a sense of the main tones and shapes, and consequently to evaluate the likely success of the idea were it to be reworked as a painting. Where I need colour reference, I add notes. For instance, I might write 'strong, dark area here [indicating the area with an arrow and a jagged outline], burnt sienna plus French ultramarine'.

Often my sketches consist of only a few lines – just enough for me to assess the strength of the composition. But there are occasions when I need more detailed information, and therefore a much more resolved drawing is required. This was so when I painted *Fine Autumn Day, Clayworth Wharf, Nottinghamshire* (page 117), for example. The boat had a very tricky perspective, and it was essential that it be accurately observed and drawn. So I began with my sketchbook, and made a careful reference drawing.

Scope and Variety

Wherever you are there is usually something interesting to paint, even if it requires a little imagination and skill to tease out the composition with the most impact from the available subject matter. Often one of the greatest difficulties on a painting trip is selecting precisely what to paint, given the huge choice of possible subjects. The danger with such scope and variety is that it leads to indecision, and perhaps to thinking that there might be an even better subject around the next corner or in the next village. But this, of course, means wasted time and energy. So my advice is that, having chosen to go to a particular location, keep to that decision: stay there. Generally, if you look and think about what is there, you will discover plenty of good ideas.

It is exciting when you find something different in an old hunting ground. But I think the greatest joy is to go to new places. *Pathway to a Shingle Beach, Loch Linnhe* (above) demonstrates this point. I noticed this subject as I drove past in my car. Usually when you see things from the car they are disappointing when you return and look at them more closely, but this scene was an exception. I particularly liked the path leading through the trees down to the loch, and the contrasts of light with the dark, mysterious area of shadows.

I balance visits to new areas with occasional trips to one or two favourite haunts such as Staithes. However, when I am at Staithes I often do a lot of walking to find viewpoints that are unusual and original, so that the results are quite different from the typical picture postcard images that one sees. As well, there are always different light effects to explore – I especially like light coming low across the harbour. I think there will always be new challenges and possibilities at Staithes. After all, its most famous painter, Laura Knight, worked there for a period of more than eight years.

Pathway to a Shingle Beach, Loch Linnhe
Oil on board, 25.5 x 35.5 cm (10 x 14 in)
I noticed this enticing scene when I was driving past in my car, so I returned later to make the painting.

Landscapes

Landscape views can be seductively pretty, but generally such scenes do not make good paintings. Instead, look for subjects that give you form and structure, a strong composition and interesting qualities of light and colour. In most of my landscapes the colour is subtle and harmonious, worked from a limited palette, as in *Fegla Fach Farm, Barmouth Estuary* (below). For me, subjects that work particularly well are those that involve a combination of solid ground, water and reflections. Often a simple idea, such as the one shown in *Ponies by the Idle, Misson* (right), provided it is painted sensitively, is the most successful.

When painting *plein-air* landscapes there are usually practical considerations to address. For instance, in very hot conditions you will need to find a spot where you can work in the shade, while if there is a gusty wind it is obviously advisable to stabilize your easel in some way. I quite often paint in fairly precarious situations – on steep hillsides or clifftops, for example – and because I have some experience in climbing I normally have a climbing sling and karabiner with me, which I can attach to myself or the easel. Naturally safety should always be the first concern, and on this point I would also recommend the idea of painting with a companion or a small group of artists, rather than on your own. For various reasons it can be unwise to paint on your own in a lonely place.

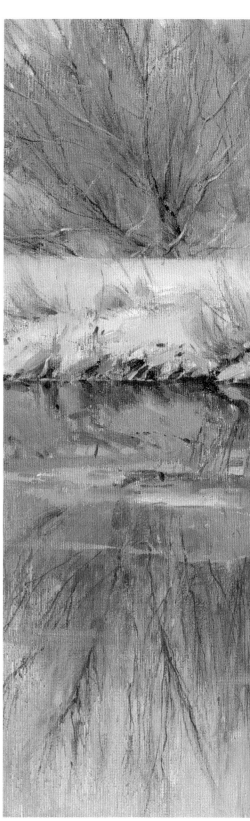

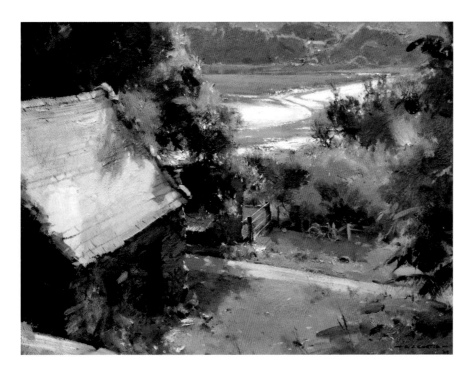

Above: *Fegla Fach Farm, Barmouth Estuary*
Oil on board, 35.5 x 40.5 cm (14 x 16 in)
I prefer to avoid the rich greens of the summer landscape and instead I look for subjects that involve gentler, harmonious colours.

Right: *Ponies by the Idle, Misson*
Oil on canvas, 46 x 61 cm (18 x 24 in)
This was painted for a Christmas card, so it is slightly more poetic and picturesque than would normally be my style.

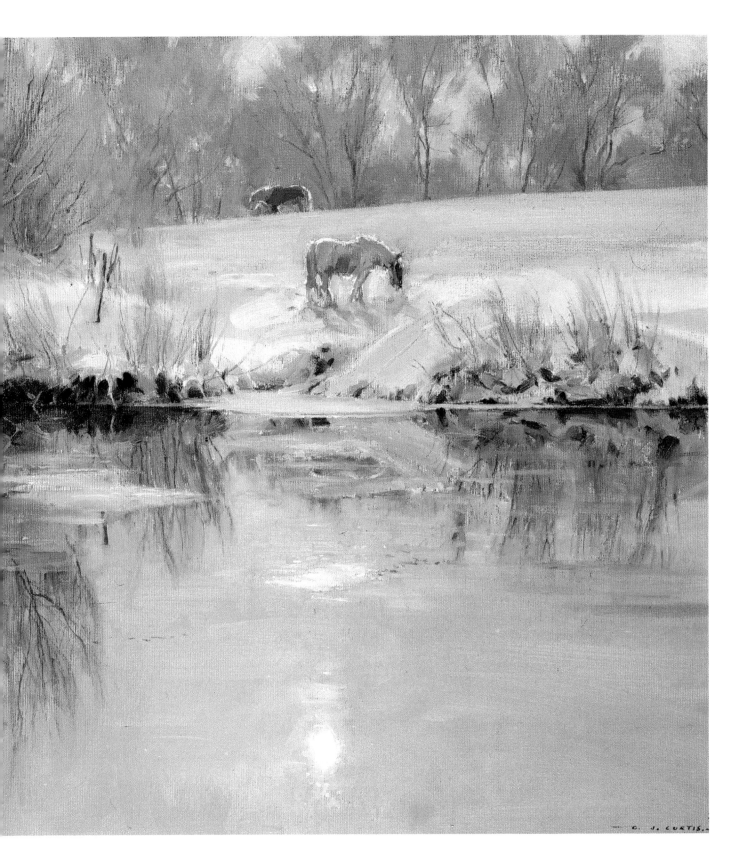

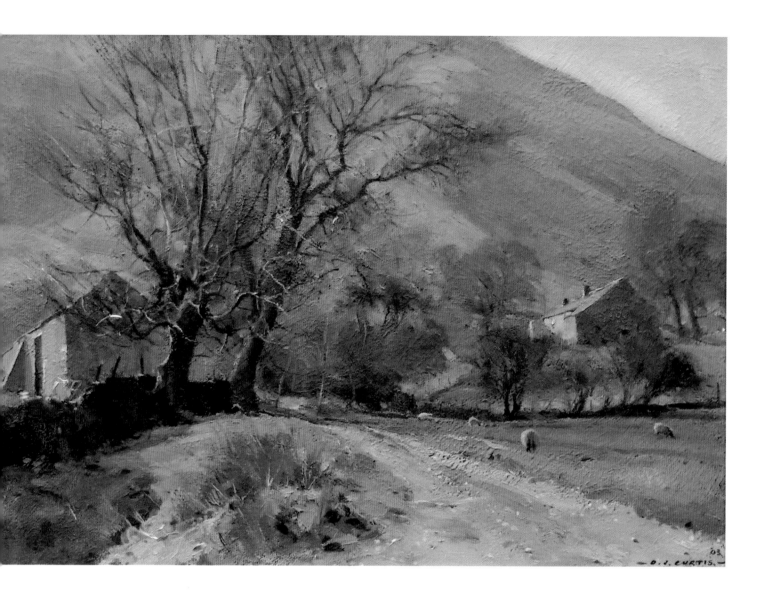

Winter Landscape in the Edale Valley, Peak District
Oil on board, 25.5 x 35.5 cm (10 x 14 in)
I love this type of subject: it typifies the character, remoteness and colour of the midwinter upland landscape.

There are two main areas that can be problematic for landscape artists: creating the correct relative scale of different elements; and mixing and using greens. A common mistake is to make figures, trees, buildings or similar objects in the middle distance too large in proportion to the general context of the scene, or other items in the foreground. Where such objects need to be included, cross-check the size of one against another to ensure that the relative sizes make sense. Note too that capturing the feeling of space and depth in a landscape relies on observing and understanding how the scale, tonal values, colours and degrees of detail are influenced by their relative distance from you. Typically the strongest colours and the most detail are found in the foreground area, and these aspects become more subdued as you look further into the distance – the phenomenon known as aerial perspective.

Green is a difficult colour to use. It can so easily become vibrant and overpowering in a landscape painting. My advice is always to paint a green less green than it actually looks – more towards an ochre. Look for the warmth within an area of green and intensify that slightly. Avoid using colours such as Hooker's green or emerald green. Instead, mix all the greens from a blue/yellow base. For example, I often use a mix of French ultramarine and raw sienna, sometimes enriching this with a touch of viridian or lemon yellow. Alternatively, I might start with olive green but add some raw sienna and a little lemon yellow.

Coastal Views

I have always enjoyed painting coastal views, and one of the reasons for this is because they are, in a sense, something of a social snapshot. Essentially the subject matter is either people having fun on the beach – society at leisure – or fishermen and man's relationship with the sea. It is the interaction of these two activities that particularly appeals to me. As well, there is the challenge of capturing the changing moods of the sea, and working from what is, in effect, a subject that is constantly in motion.

Morgan Porth Beach and Trevance Cliff, North Cornwall
Oil on canvas, 46 x 61 cm (18 x 24 in)
The challenge here was to capture the effect of the evening light and atmosphere – mostly by using carefully blended areas of colour, but also some glazes.

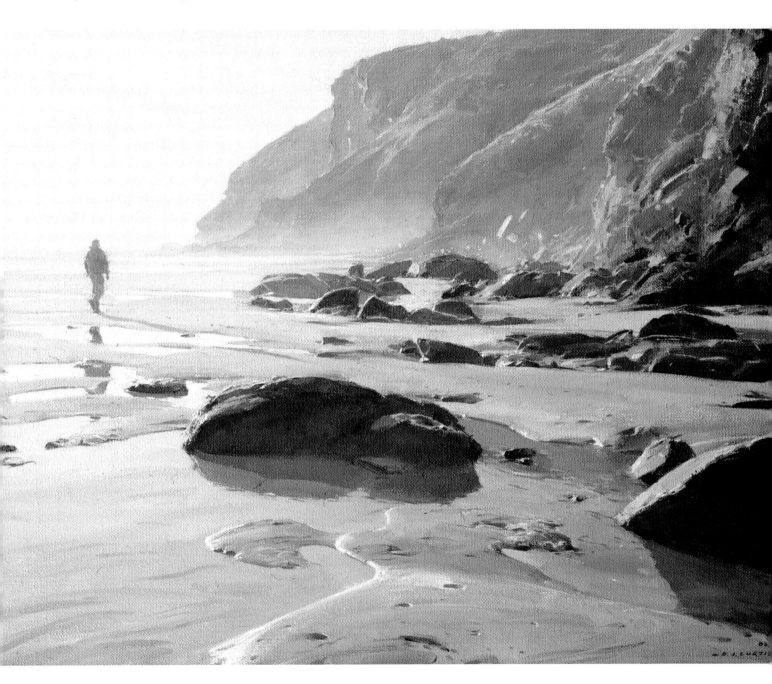

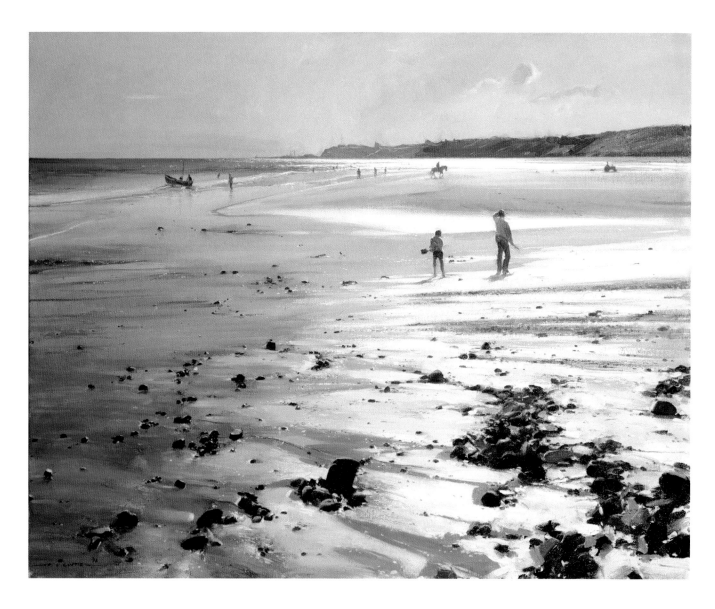

Above: *Figures on the Beach, Sandsend*
Oil on canvas, 61 x 76 cm (24 x 30 in)
This scene has very little content as such:
essentially it is about capturing the effect of
glancing light on the wet sand.

Left: *Towards Whitby Headland*
Oil on canvas, 61 x 76 cm (24 x 30 in)
Figures are always a useful asset in coastal
views, adding interest and enhancing the
sense of scale and space.

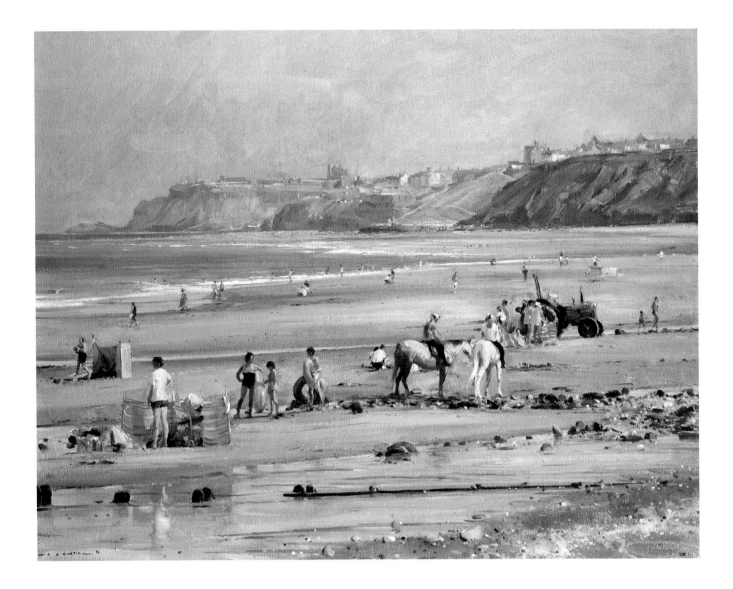

For me, coastal views are an all-year-round subject. I like the emptiness of winter beaches, where there may be just a solitary figure, but equally I like the more colourful, active summer beaches. Whatever the location and activity, light is always a feature. My favourite type of light is a glancing light that catches the wet sand, as in *Figures on the Beach, Sandsend* (top left) and *Towards Whitby Headland* (bottom left). You will notice that in both of these paintings there is not a lot of obvious subject matter; success relies on making the most of what is there, of moving around to find some foreground rocks or other features.

The figures in these beach paintings are sometimes based on figures I observed at the actual location or, more often, they are introduced from other sources – from reference sketches, drawings and photographs. The scale and placing of the figures must be carefully assessed in relation to the overall composition, and I spend some time working this out. Occasionally I make a line drawing on a separate sheet of paper, cut this out, and place it in different positions on the canvas or board to see how it looks.

If a figure is too large it will destroy the illusion of space in the painting. Another important point about figures is not to overdo the idea. Generally a few well-placed figures work best, and even in a more crowded beach scene, as in *Summer Fun, Sandsend* (above), the scale and grouping of the figures is a vital consideration.

Summer Fun, Sandsend
Oil on canvas, 46 x 61 cm (18 x 24 in)
Where there are lots of figures, you need to think carefully about their scale, placement and grouping.

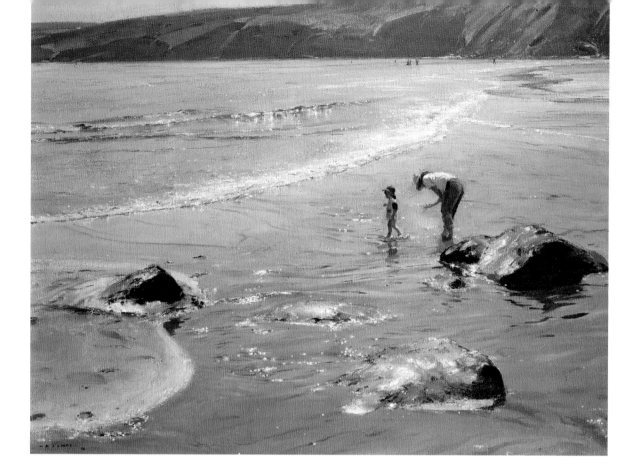

Seascapes

I own a boat and I have always been interested in the sea, although mainly coastal waters rather than the open ocean. So when painting I tend to concentrate on views along the foreshore and choose subjects in which I can exploit the subtle effects of light, and the translucency of shallow water as it breaks over the sands. Occasionally I paint in Cornwall and other areas where the light is quite intense, but generally I work along the East Coast, where the light tends to be 'milky'. To compensate for this I usually slightly heighten the colour key that I use.

Water can be a difficult subject to paint convincingly, but like everything else, in the first instance success depends on observation. With the nearer, shallower water, as in *The First Paddle* (above), there is always a hint of colour coming through from the sand or pebbles beneath, which in fact adds to the sense of shallowness. However, as you look further out to sea you will find that the light source from the sky is reflected in the water, and consequently there is far less local colour. Essentially with this type of seascape success relies on checking the transition of colour from shoreline to horizon and deciding which colour is most appropriate for each area. Typically, the subtle colours of the foreshore give way to blues and viridians further out to sea.

For most seascapes I start with a biscuit-coloured ground – normally a mix of raw sienna with a touch of permanent magenta and cerulean blue. I apply this in a free, fairly diluted way to the canvas or board, and being a warm, neutral colour it creates a useful unifying tone across the whole surface. This colour readily takes an overlay of blue for the sky area, and in the foreground it also helps to suggest the effect of sand beneath the water. I generally keep the sky area quite simple, so that the accent is on the foreshore figures and other elements of interest, as in *Paleokastritsa, View to the West, Corfu* (top right).

The First Paddle
Oil on canvas, 46 x 61 cm (18 x 24 in)
To paint shallow water convincingly you need to take into account the colour beneath.

Above: *Paleokastritsa, View to the West, Corfu*
Oil on canvas, 61 x 76 cm (24 x 30 in)
For most seascapes I prepare the board or canvas with a warm, neutral ground colour, and I focus most of the interest on the foreshore.

Left: *Stream to the Sea, Sandsend*
Oil on canvas, 61 x 76 cm (24 x 30 in)
Atmosphere is everything in a seascape, and success mainly relies on the ability to capture the momentary effect of light.

Summer Evening, Abersoch
Oil on canvas, 51 x 71 cm (20 x 28 in)
With a harbour subject I prefer a falling tide,
as this allows me more time to fix the position
of the boats and any other important elements
of the composition.

Harbours

With harbour subjects the main difficulty is the changing tide, and consequently one of the first considerations must be planning how best to deal with this. Often I choose to work when the tide is falling, as in *Summer Evening, Abersoch* (above), which was one of many pochade and box-easel paintings that I made during a very successful week's stay at Abersoch, North Wales. The receding water leaves the boats stranded on the mud flats or sand, and so allows a reasonable timespan for you to place all the elements of the composition before the water level rises again and alters everything.

Also as part of the initial planning, it is essential to think about the viewpoint, and the practicalities of working from a certain spot. Painting from a vantage point on the mud flats within the harbour itself can give some very interesting compositions, but of course you must keep an eye on the tide and make sure of your line of retreat. More than once I have been caught off guard – so absorbed in my painting that I have not noticed the incoming tide until it was lapping around my easel! Obviously it would be safer to choose a higher place to work from, and in fact, for *Summer Evening, Abersoch* I found that the subject worked extremely well when viewed from the nearby bridge. Moreover, it gave the added advantage of a high horizon, which I always relish for the opportunity of avoiding a dominant sky composition. The experience was made all the more enjoyable by the effect of the evening light and the long shadows, which added fortuitous directional lines.

If, in contrast, I have to paint with the tide coming in – whether through necessity or choice – then the first priority must be to fix the position of the boats and the water level. Later, as the water rises, the boats will be tilted and twisted at different angles, and their position altered in relation to their surroundings. Speed is of the essence, therefore, and I quickly block in the boats first, save perhaps for the final highlights and details, and then work on the background elements, such as the harbour wall with the buildings and sky above, all of which are unaffected by the changing tide.

The other main factor concerning harbours is deciding exactly what to include and what to leave out. Often harbour views are quite complex and so, to create an effective composition that can be completed in the time available, it is necessary to simplify the scene to some degree. This requires discipline and

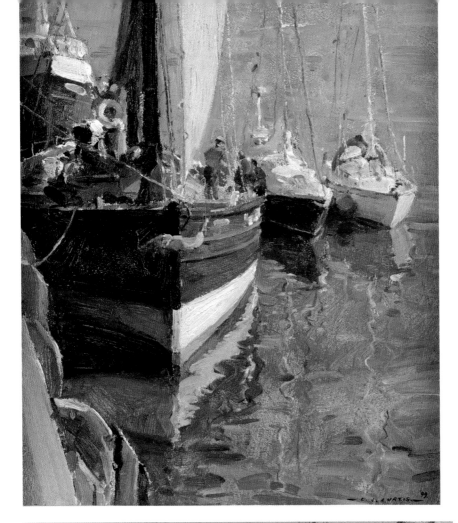

The Reaper in Whitby Harbour
Oil on canvas, 76 x 61 cm (30 x 24 in)
Very often in a harbour scene it is a matter of selecting which boats will make the best composition. In fact, there were several other boats in the background of this view that I decided to leave out.

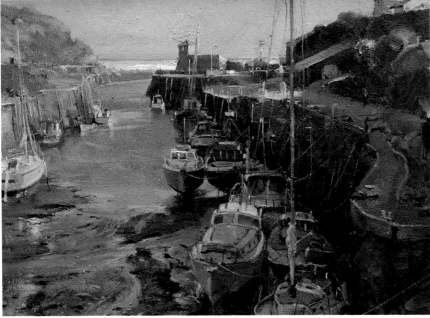

First Light, Amlwch, Anglesey
Oil on board, 30.5 x 40.5 cm (12 x 16 in)
The grouping of the boats was important here too, adding to the rhythm of the composition.

experience. For example, in *The Reaper in Whitby Harbour* (above), an on-site painting that I made while sitting on the harbour steps, various other boats were visible behind the large vessel in the foreground, but to include them all would make a very cluttered composition. So I opted to keep just the two on the right, and painted the rest of the background as blue sea.

Boats

To my mind, as a boating man, this is the ultimate subject matter. The beautiful shapes of different boats, how they are arranged in a harbour and sit in the water, and their wonderful reflections and particular relationship to their surroundings – these are all fantastic aspects to explore. I am in awe of the way boats are built, and my interest spans every kind of vessel, from derelict boats left to rot in the water to fishing boats and pleasure craft.

I have no doubt that to paint boats successfully it is a great help to know how they are made, to appreciate what is going on beneath the surface. It is rather like a figure painter or sculptor benefitting from a knowledge of human anatomy. If you own a boat you soon begin to understand things about its structure, and you become aware of its relationship to the water and response to different sea conditions. This knowledge informs the way you draw boats and ensures that they look convincing.

Once again, observation is important. Boats must be well drawn, for if there is anything wrong with the perspective, foreshortening or other aspects, it will be immediately noticeable to anyone viewing the painting and will undermine the impact you intended. The best way to gain confidence is through looking and drawing. Go to boatyards, harbours, or marinas and, through observation and sketching, gradually build up a stock of reference material as well as a good knowledge of different boats.

This is what I did. I have spent a great deal of time looking at the skeletons of boats in boatyards and watching how they were built, repaired and refitted. And I still make sketches of interesting boats or details, such as an unfurling sail, whenever I come across them. As always, my advice is not to rely on photographs, but to go out and look at the real thing!

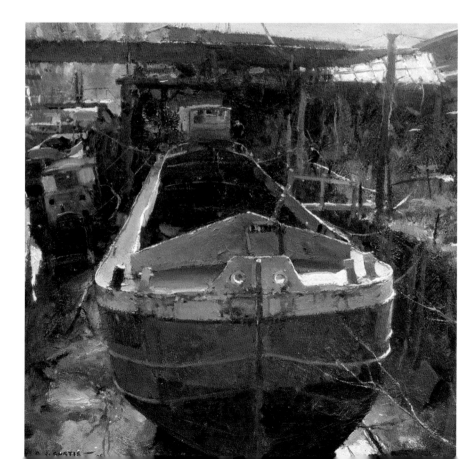

Waddington's Yard, Swinton Lock
Oil on board, 35.5 x 35.5 cm (14 x 14 in)
I have spent many happy hours looking around boatyards and watching how boats are built and repaired.

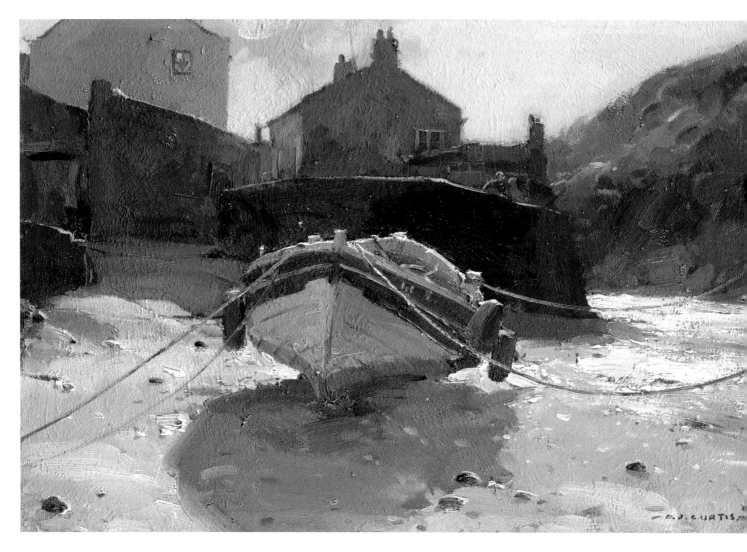

Above: *In Conversation, Staithes*
Oil on board, 20.5 x 30.5 cm (8 x 12 in)
With boats it is very important to observe the
shape and structure carefully, and ensure that
these are well drawn.

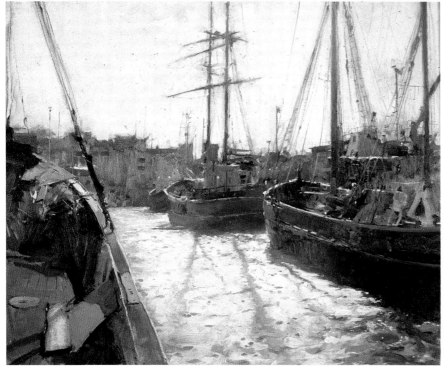

Left: *Tall Ship Moorings, King Edward
Dock, Hull*
Oil on canvas, 46 x 56 cm (18 x 22 in)
For this painting I worked from another boat,
which gave me the best vantage point, with
the shadows falling across the sparkling water.

Buildings

My preference is for scenes that involve different angles and relationships between ordinary vernacular buildings, rather than important architectural set-pieces. I like the idea of the blocks and structure of buildings being represented with broad brushstrokes, and thus seeming an integral part of the painting, rather than being too precise and detailed. I would say that my most successful paintings of buildings are those in which I can rely on suggestion and painterly qualities, instead of having to aim for a faithful reproduction.

This point is demonstrated by comparing two paintings shown here. You can see from *Town Hall Square, Bruges* (below) that I do occasionally paint grand city architecture, although I find that the finished pictures inevitably have a tighter feel than my paintings of Staithes and similar harbour and village scenes.

Naturally, painting technique is influenced by the scale of work and the type of subject matter. Thus, because of the character and detail of the fine buildings surrounding the busy square in Bruges, I felt there was no alternative but to opt for accuracy in placing the windows and other features. With such a well-known subject, a freer approach would simply not have worked. The result is different to my usual style of painting, but nevertheless successful in its own way.

Town Hall Square, Bruges
Oil on canvas, 76 x 70 cm (19¾ x 27½ in)
There is something impressive and appealing about grand city architecture, but it is difficult to paint with the same freedom and spontaneity that is possible with a small village scene.

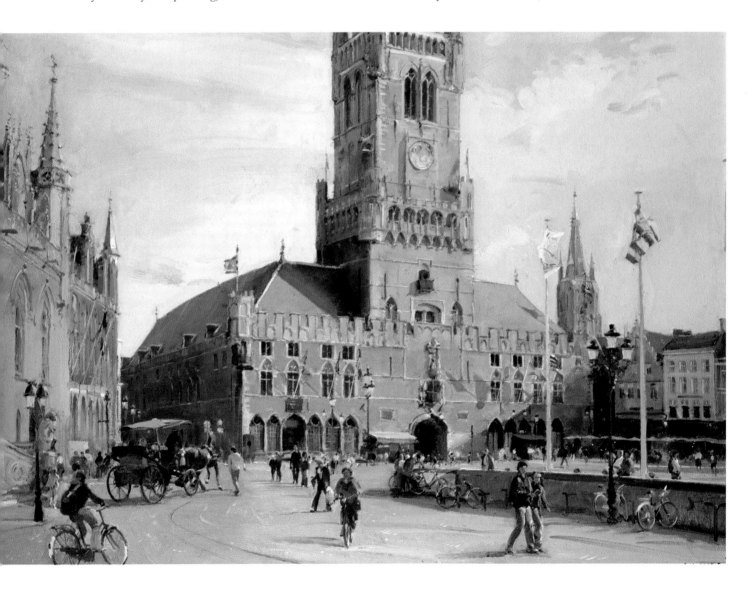

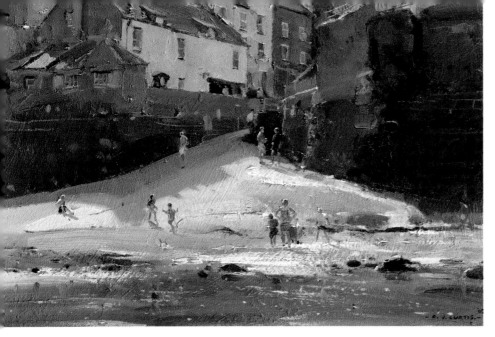

The Slipway, Robin Hood's Bay, Whitby
Oil on board, 20.5 x 30.5 cm (8 x 12 in)
I was so absorbed in this painting that I almost got stranded by the incoming tide! The main appeal was the light foreshore, enhanced and contrasted by the dark buildings behind.

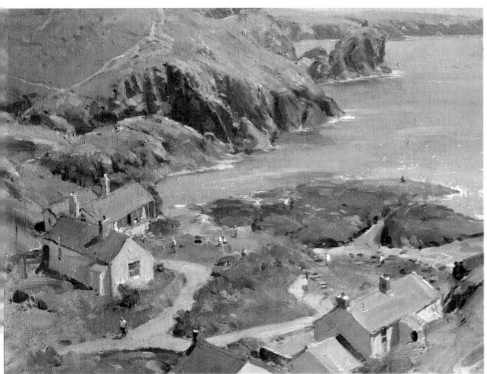

High Aspect over Kynance Cove, Cornwall
Oil on board, 30.5 x 40.5 cm (12 x 16 in)
This is more my preferred approach to buildings. Painting *plein air* and from a high viewpoint, I was able to work in a much looser, more painterly way.

Now look at *High Aspect over Kynance Cove, Cornwall,* (above) which demonstrates my preferred approach. It is much looser in style and painted *plein air*, with an emphasis on capturing mood and atmosphere. The buildings and surrounding landscape are as one, and thus, in my view, the whole composition works in a much more harmonious and exciting way than that of *Town Hall Square, Bruges.* But of course this approach is far easier and more in keeping when the buildings are simpler, smaller scale and randomly placed.

So, with buildings, there may well be times when you will need to adjust your painting style. As illustrated, this especially applies when the accuracy of architectural features is likely to be an essential contributing factor to creating a successful result. The alternative is to be particularly careful when selecting subjects, to ensure that they suit the way you like to work.

Towns

For townscapes the ideal painting spot is one that offers an exciting, challenging view and at the same time shields you to some extent from inquisitive passersby. In the main, town scenes are difficult subjects to attempt, and certainly not everything you come across is attractive and will make a good painting. As with all subjects, 'simple' is best, so you need to be selective. Therefore my advice is to focus on a compact, interesting composition, as I have done in *The Corn Exchange, Doncaster* (below left) and *Saturday Morning, Howden* (below right), rather than trying a wide-angled view involving a complicated arrangement of buildings, figures, vehicles and all the other things that you might see in a town.

I was lucky enough to find a quiet doorway in which to set up my box easel and paint *The Corn Exchange, Doncaster*. No artist likes to be constantly interrupted while working, and the best way to avoid this is to position yourself where it is difficult for people to stop and engage you in conversation. When you have been painting *plein air* for a number of years you gradually become hardened to this sort of thing, and simply offer a few curt but polite stock-in-trade answers. A trick I sometimes use, if I want to avoid answering questions about the painting, is to hold a spare paintbrush in my mouth!

Below left: *The Corn Exchange, Doncaster*
Oil on canvas, 61 x 51 cm (24 x 20 in)
In towns, look for a spot where you can work without too much disturbance, and choose a view that is not too complicated. I painted this scene from the relative peace of a nearby doorway.

Below right: *Saturday Morning, Howden*
Oil on board, 40.5 x 30.5 cm (16 x 12 in)
Try to avoid large, empty foreground areas by introducing figures, vehicles or other features of interest.

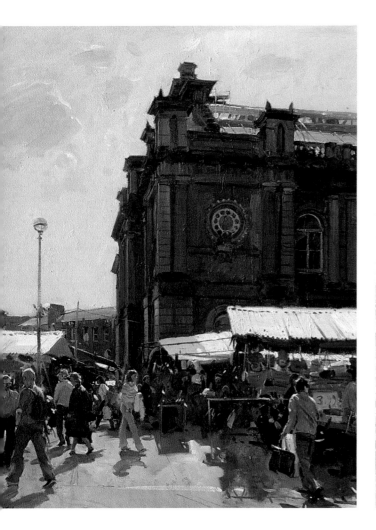

Morning Sun, Polruan, Cornwall
Oil on board, 25.5 x 35.5 cm (10 x 14 in)
This was painted from a very tricky viewpoint, with the pochade box balanced on a hedge. But I think the result was worth the trouble!

Apart from all the usual considerations when painting outside, with townscapes I am very conscious of finding a group of buildings that has an interesting skyline and will create a composition in which there is adequate foreground activity. Inevitably, most townscape views involve part of a road in the foreground, and this can prove a difficult area to deal with. A huge expanse of tarmac is obviously not the most exciting lead-in to a painting. Thus I usually introduce figures or other features of interest, such as the vintage car in *Saturday Morning, Howden* (left).

I liked the vertical composition in this painting. In addition to the shapes and relationships of the different buildings, another feature that impressed me was the intriguing slanting shadow on the white wall, just off centre. With this sort of perspective view it is obviously important to start with some drawing to establish the main lines and angles. These lines were lightly placed with a No. 2 bristle brush, and then I could begin work on blocking in the sky area and the other main shapes. The car was added later, from a photograph. The car actually belonged to a painter friend of mine, and it did in fact arrive in the street while I was painting, which gave me the idea to include it as a welcome touch of foreground interest.

Figures

I include figures in the majority of my paintings. They are often the focal point in a composition, they help create a sense of scale and they add interest and movement. The essential thing to remember about figures, as I have stressed before, is that they are painted in the same manner as the rest of the work, with the same degree of detail in the brushwork, so that they appear as an integrated part of the whole rather than an afterthought.

Sometimes I work directly from the figures at the scene, quickly adding them when they take on a stance or position that will enhance the impact of the composition. For example, notice how the figures are loosely described in *Deckchairs for Hire, Sandsend* (below), which I painted sitting on the sand, looking up the beach. This is a small, pochade-box study, with the figures worked in very economically with just a few brushmarks. As I painted, whenever I noticed someone standing in a particularly interesting way or in just the right place for the composition, then bang, bang, bang – three strokes and they were part of the painting!

On other occasions, especially with studio paintings, I add figures from the many sketchbook reference studies that I have accumulated over the years, or I may work entirely from memory. But, as in *Sledging on Gringley Beacon* (right), I still want them to look a natural part of the scene, and I take care to ensure they are not overworked. In a landscape painting the figures are usually quite small, and therefore the amount of detail is minimal. You cannot see the folds on clothing, for example, or even the features of the face, or the hands and feet. Adding unnecessary details like these will make the figures look disproportionately resolved for their surroundings, and they will seem rigid and lifeless.

In my portraits too I keep to a painterly approach, with loose and spontaneous brushwork. I love portraiture, and in fact I paint quite a few portrait commissions as well as subjects that I choose myself. The subject in *Study of Andy* (below right) is my old painting mentor seated in his garden, and I am pleased that I have caught something of his character. Perhaps this was not difficult, because I knew him so well, but certainly this is a painting that has a lot of significance for me, and therefore not one that I would ever sell.

Deckchairs for Hire, Sandsend
Oil on board, 20.5 x 30.5 cm (8 x 12 in)
I added these figures as and when they were in the right position to enhance the impact of the composition.

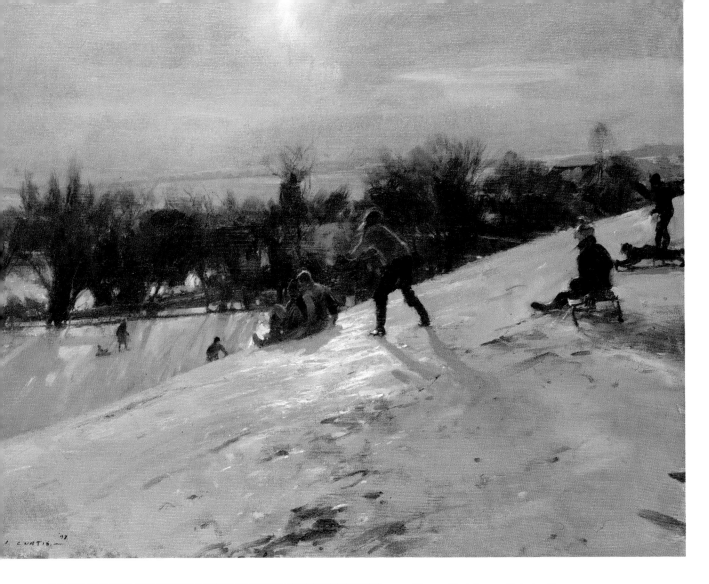

Above: *Sledging on Gringley Beacon*
Oil on canvas, 46 x 56 cm (18 x 22 in)
In all my paintings I want the figures to look a natural
part of the scene, and so I describe them fairly loosely.

Left: *Study of Andy*
Oil on board, 30.5 x 25.5 cm (12 x 10 in)
In my portraits too, I aim for brushwork that is as lively
and painterly as possible.

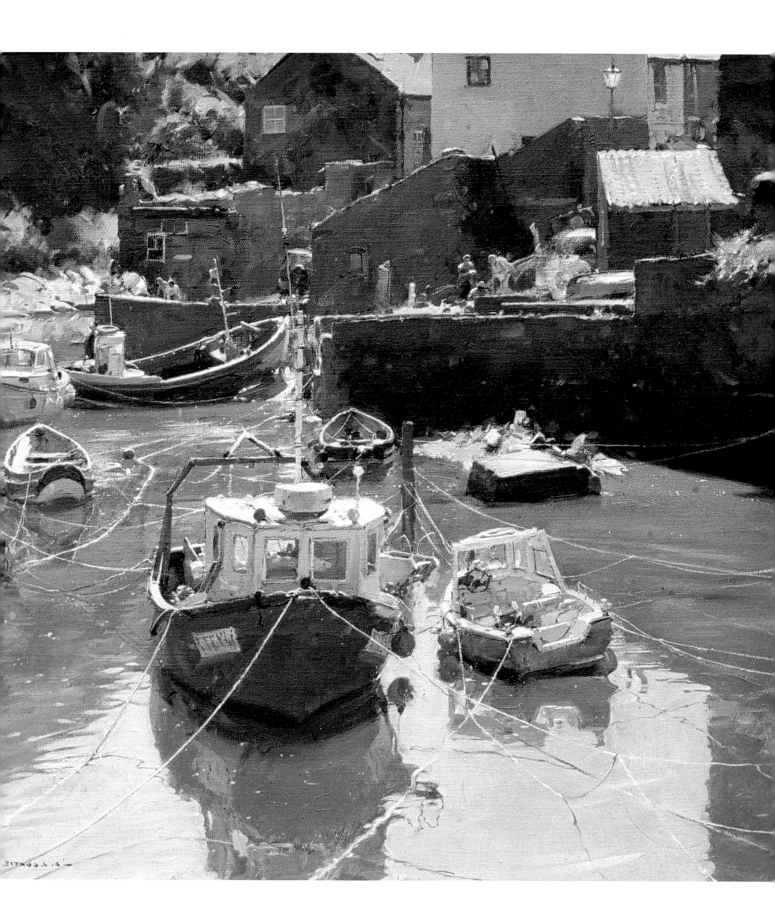

5 Painting *plein air*

There is nothing better than painting *plein air*. For me, it is the most rewarding and enjoyable way of working. When painting outside there is a heightened awareness of everything, a more real, living experience of the subject matter. Moreover, being able to immerse yourself in the sense of place, the context of the subject and the associated sights, sounds and smells – rather than having to try to remember them some time later – enables you to paint with greater sensitivity and conviction.

My love of *plein-air* work is perfectly demonstrated by *The Lion Rock, Kynance* (page 106), which was one of 14 paintings that I completed during a memorable four-day trip to the Lizard peninsula in Cornwall. The light was stunning, the weather fine and settled, and wherever I looked there seemed to be wonderful subjects to paint. This one, near Mullion Cove, was in fact my fourth painting of the day. On the recommendation of the car-park attendant I found a spectacular viewpoint, right on the edge of the cliff – a sort of natural armchair seat, formed within the rock face. It was a precarious place to paint, but the subject, with its fabulous shapes and shimmering light, was irresistible.

Rising Tide in the Beck
Oil on canvas, 51 x 51 cm (20 x 20 in)

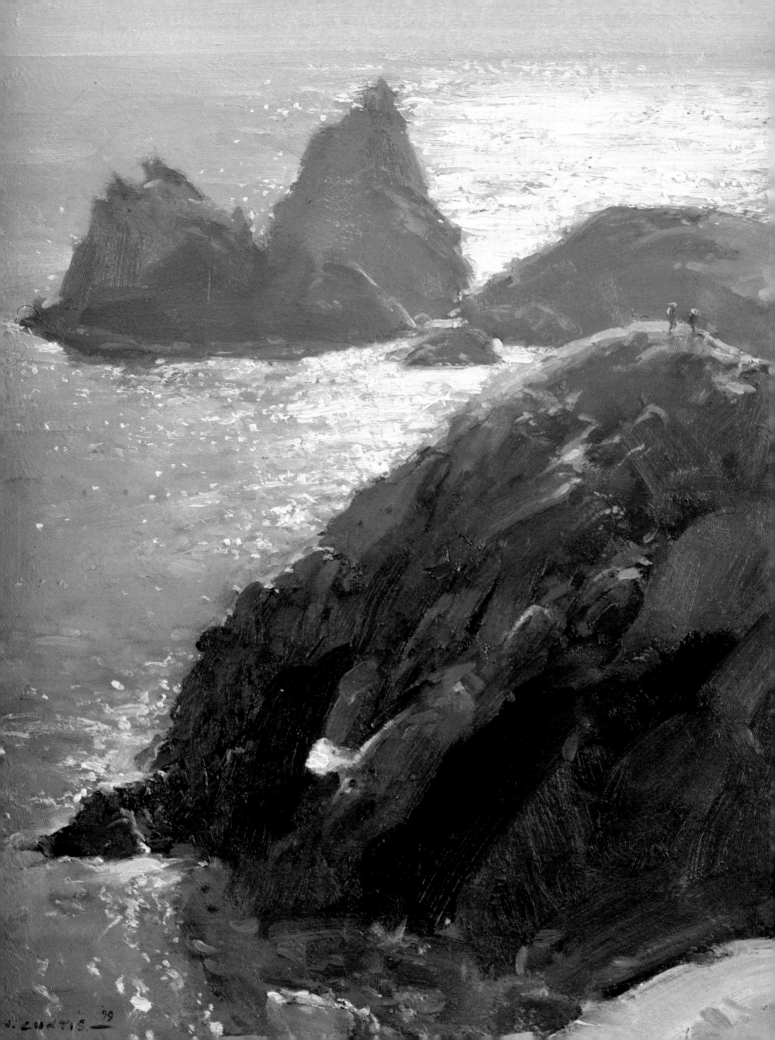

J. CURTIS '99

The more *plein-air* painting you do, the more you learn how to extract from the scene the essence of the subject and to express it in a lively, interesting way. The important things to concentrate on are good composition, bold shapes and expressive brushwork. I often start by squinting at the subject to see it in its basic form, blocking out the unnecessary detail. Being able to size up a subject and assess how best it will work as a painting is obviously the first essential skill for every *plein-air* painter. Take *Moorings on the Chesterfield Canal* (below), for example. It was a sharp, frosty morning, and initially I thought everything along this canal looked very horizontal and unlikely to make a good painting. But then I found these two boats with the light separating them and creating a lot of foreground interest in the form of a glinting reflection. This, I felt, made a much more balanced and perfectly acceptable composition, so I soon began working from my pochade box, using a 25.5 x 30.5 cm (10 x 12 in) board.

Left: *The Lion Rock, Kynance*
Oil on board, 30.5 x 25.5 cm (12 x 10 in)
This epitomizes the absolute joy of *plein-air* work. It was painted from a spectacular viewpoint right on the edge of a cliff.

Below: *Moorings on the Chesterfield Canal*
Oil on board, 25.5 x 30.5 cm (10 x 12 in)
The first essential for any *plein-air* subject is to assess how best it will work as a painting. Here, the glinting light on the water in the foreground made all the difference to a fairly low-key subject.

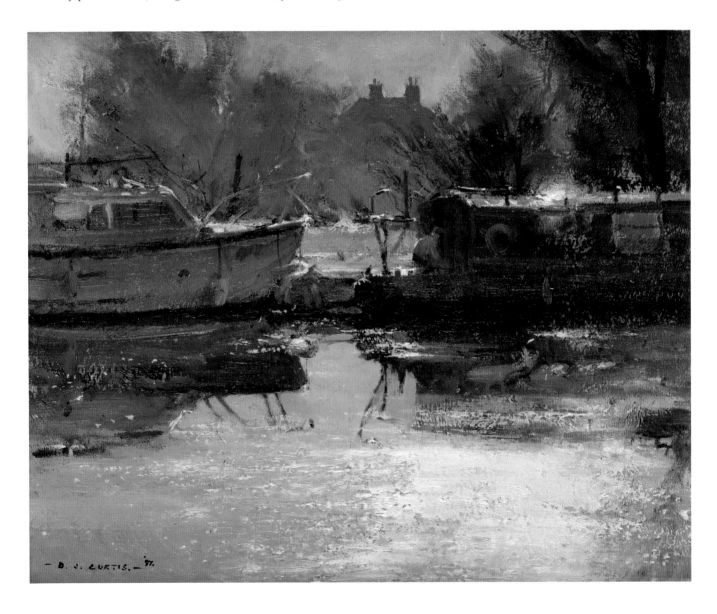

Practical Considerations

For *plein-air* work the best advice I can give is to keep your painting equipment to the absolute minimum. Bear in mind that for this type of work there are usually time constraints, and therefore you will need to paint quickly, essentially using a 'one-hit' technique and a very limited palette of colours. As well, you may have to carry equipment some distance, or over rough terrain, in which case weight will be a consideration.

If I am painting near the car I often use my box easel and work on a reasonably large board, say 30.5 x 40.5 cm (12 x 16 in). But if I am walking some distance I usually take a rucksack in which I can carry a pochade box and a lightweight sketching easel that folds up. I prefer to stand and work at an easel, so that I can step back and assess how the painting is progressing every now and then. However, in windy conditions it can be hard to keep an easel stable, so I work at the pochade box propped on my lap. Another advantage of a pochade box is that it will hold two or three wet paintings, although these have to be of a certain fixed size, matching the size of the box.

Even when I am not out specifically on a painting trip, I normally have a small pochade box with me, and this contains everything I need for a quick study, say 18 x 25.5 cm (7 x 10 in). So, if I am out somewhere and find that I have some time to spare, I will probably look for something to paint. This was the case with *A Shady Corner, The Pannett Gallery* (below). I hate wasting time, and when I found I had an hour to wait before a painting society meeting, I decided to see if there was anything nearby that would make a suitable subject to paint. At the top of the steps to the gallery I discovered a delightful little garden. When I had blocked in the main shapes and subsequently finished most of the painting I persuaded a couple of my painting society colleagues to sit on the bench so that I could add some figurative interest.

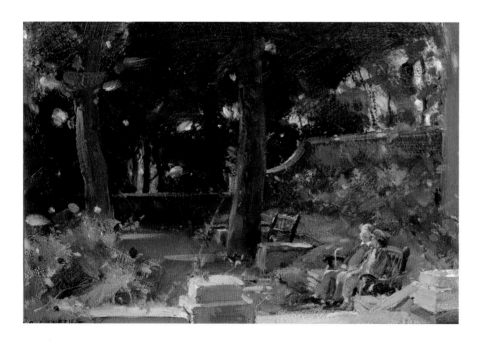

A Shady Corner, the Pannett Gallery
Oil on board, 18 x 25.5 cm (7 x 10 in)
Here is an example of an opportunist painting. I had some time to spare before a meeting, so I got out my pochade box and found something to paint!

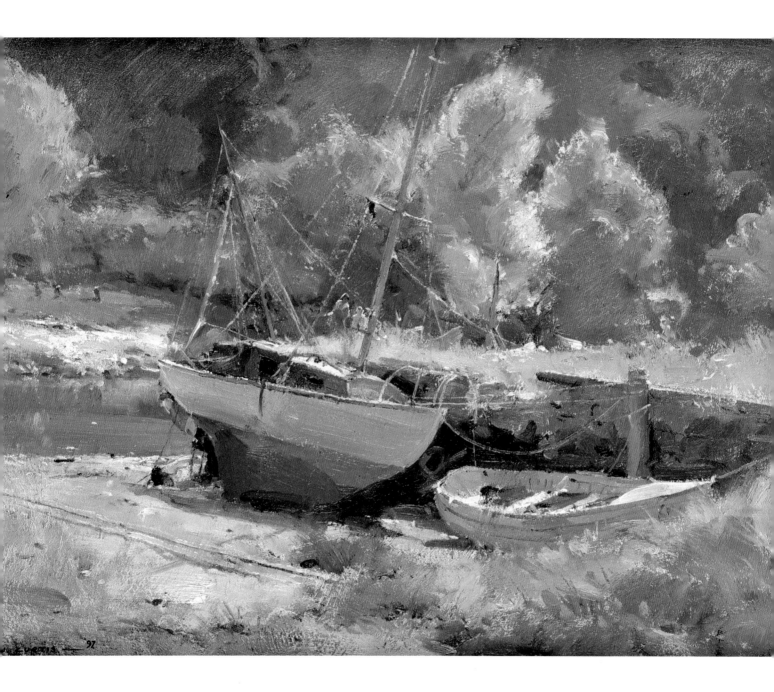

Low Tide on the Esk
Oil on board, 30.5 x 40.5 cm (12 x 16 in)
This was a harmony in green and grey, with
the boats perfectly fitting their context.

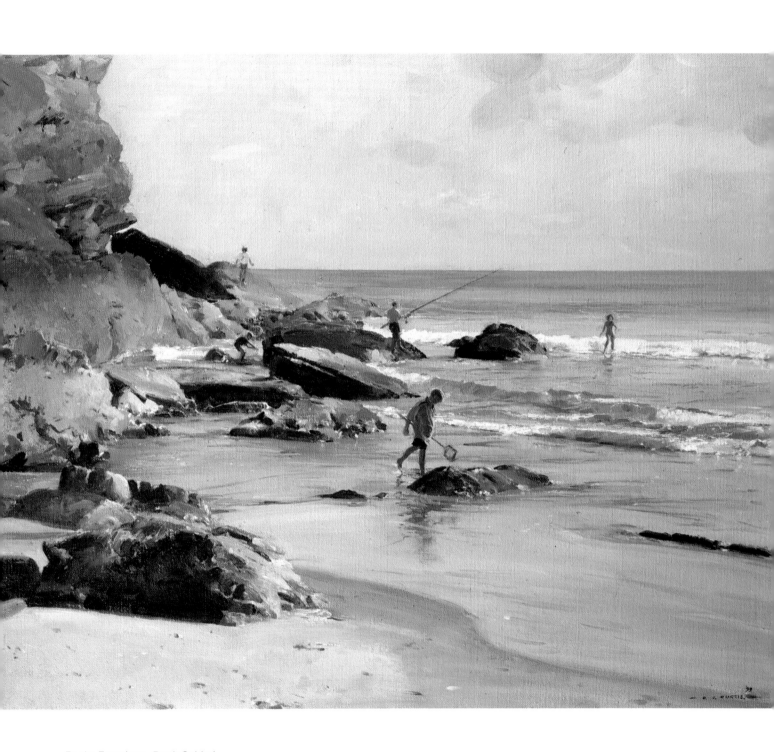

Rocky Foreshore, Porth Ceiriad
Oil on canvas, 61 x 76 cm (24 x 30 in)
As always with beach scenes, the placing of the
figures in this composition was a key consideration.

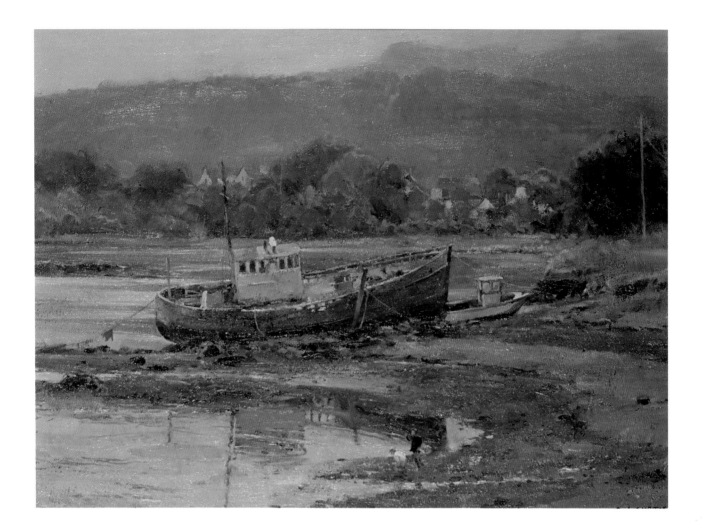

Speed and Confidence

Winding Lane above Hathersage, Peak District (page 113), which I painted in early March, entirely on location, is a good example of my *plein-air* approach. This part of Derbyshire is not far from my studio and it is an area I know well. I was confident that on this particular bright, late-winter's day I would find plenty of subjects to paint.

You can see from the photograph (page 112) that the view I chose had a strong composition with some lovely directional lines and plenty of potential interest in the foreground. It included various areas of deep shadow, but I was sure that I could pluck out sufficient colour and form from these areas to complement the rest of the scene. Also, I liked the way the track provided a rhythmic movement through the composition, and how it would be possible to make use of various repetitive balancing elements. For example, the gate on the left in the foreground was balanced, though not obviously so, by the post on the right, and this idea was echoed in the distance by the two groups of trees.

Using broad, vigorous brushstrokes, I started this painting by scrubbing in the general sense of the shadowy wall on the left, and similarly indicating the gatepost and wall on the right (stage 1, page 112). Also, I suggested the flowing lines of the track, and the building and trees in the distance. You will notice that I have condensed the elements slightly from those shown in the photograph. I thought the composition would work better if I simplified the information on the right-hand side.

The Final Resting Place, Arran
Oil on Board, 30.5 x 40.5 cm (12 x 16 in)
Depending on the subject matter and the light, it is sometimes possible to return to a subject on two or three consecutive days to produce a more resolved *plein-air* work, as here.

Winding Lane Above Hathersage
Reference photograph

Stage 1: Winding Lane Above Hathersage
Using quite loose brushwork I roughly placed
the main shapes.

For this painting I chose a dry board that had been previously prepared with a
biscuit-coloured ground – a warm, neutral colour made from raw sienna with a
little permanent rose and a touch of ultramarine. I knew that this type of board
would suit a snow scene, as it would allow fairly dry, dragged brushstrokes and
feather-edge effects where the snow was receding. As you can see, it was also
important at this stage to paint the sky area, which would set the mood.

Because I was aware that the sun would gradually move round and be
face-on, thus changing the light and shadow effects, my next step (stage 2)
was to consider the key tonal contrasts and highlights. Next I added the snow
effect and the glints of light on the gateway and foreground wall, worked on the
shadow on the middle part of the wall, and defined the blueness of the shadow
on the distant snow-covered roof. Also, I looked at the tonal relationship between
the fields, sky and trackway.

Then (stage 3), I worked chiefly on the right-hand side of the painting,
aiming to make this more convincing and accurate in relation to the rest of the
foreground area. At this stage I also wanted to get the measure of the tree forms
in the distance, relative to the sky. Finally (stage 4), I introduced the figure, as
a focal point, and added slightly more detail in the foreground and on the
right-hand side.

Winding Lane above Hathersage, Peak District was completed in a single session
of about two hours. *Low Tide on the Esk* (page 109) was also a quickly executed
plein-air work, but on some occasions, particularly when the light is dull but
constant, it is possible to return to a subject two or three times. This was so with
The Final Resting Place, Arran (page 111). The boat was derelict, and so did not
move, while the water, being a loch, did not change much either.

*Stage 4: Winding Lane Above Hathersage,
Peak District*
Oil on board, 25.5 x 30.5 cm (10 x 12 in)
After assessing the painting so far, I added a
figure as a focal point, and a few general
finishing touches.

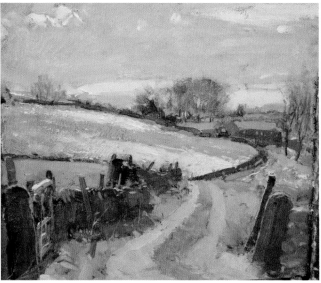

Stage 2: Winding Lane Above Hathersage
Next I considered the main tonal contrasts
and highlights, especially the tonal relationship
between fields, sky and trackway.

Stage 3: Winding Lane Above Hathersage
Now I concentrated chiefly on the right-hand
side of the painting, and the developed distant
tree forms.

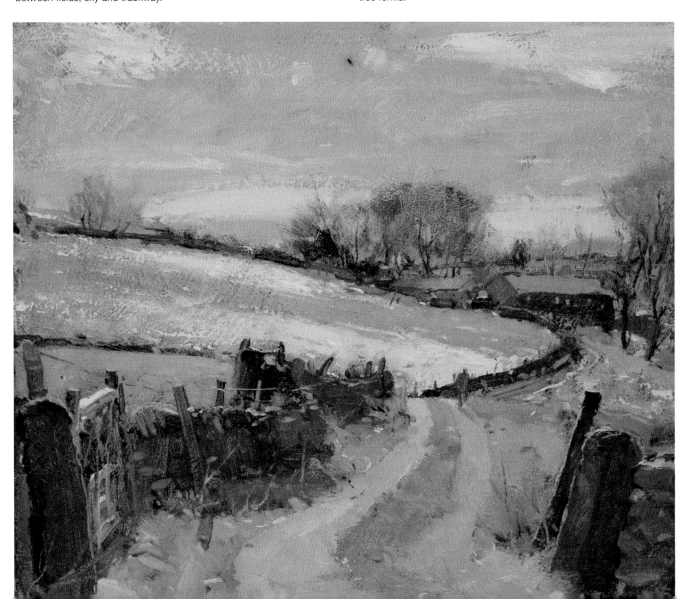

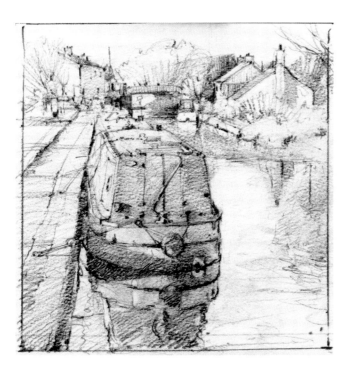

Stage 1: Fine Autumn Day, Clayworth Wharf
Pencil drawing for reference, 23 x 23 cm (9 x 9 in)

Stage 2: Fine Autumn Day, Clayworth Wharf
Initially working on site, I quickly scrubbed in the most important outlines and began to think about the main colours, and how they would interrelate.

Starting on Site

Sometimes you may choose, or be compelled, to start a painting on site but finish it in the studio – because of the scale and complexity of the subject matter for example, or due to time constraints, weather conditions or other practical considerations. When working in this way you have to ensure that you produce enough on-site painting, together with supporting reference information, to enable you to continue confidently in the studio. The other important objective is to maintain the same approach and style throughout the painting. One of the dangers when you switch from outside to inside is that the painting might lose some of its vigour.

For *Fine Autumn Day, Clayworth Wharf, Nottinghamshire* (above and page 117) I completed quite a lot of the painting on site – in fact working from the deck of my own boat, which was moored immediately in front of the one shown in the painting. So the scene was familiar territory, and I had often looked at this particular view along the canal and thought that it would make an interesting composition for a painting.

Because it was vital to get the perspective of the narrowboat correct, and because I knew that I would probably want to finish the painting in the studio,

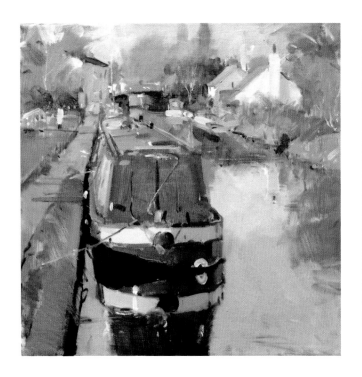

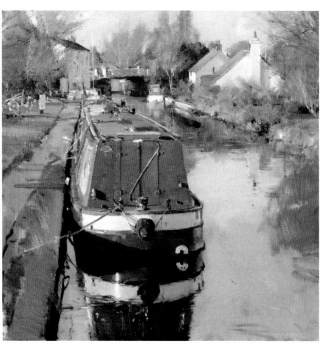

Stage 3: Fine Autumn Day, Clayworth Wharf
Next I wanted to establish a sense of the whole painting, at the same time considering further the general tonal balance.

Stage 4: Fine Autumn Day, Clayworth Wharf
Back in the studio, and with the drawing as an additional reference, I worked on defining the various shapes and colour values.

I started by making a fairly accurate pencil drawing (stage 1). From my assessment of the scene I decided that the composition worked best as a square, using a high horizon – the surrounding area on either side is mostly woodland. I liked the fact that the design incorporated lots of colour, interesting lines of perspective and good shapes. The drawing was made on a slightly textured watercolour paper, with a soft pencil, and I estimate it took about thirty minutes.

I chose a 51 x 51 cm (20 x 20 in) canvas that had been prepared with a weak, neutral-coloured ground the day before. Referring to the initial drawing and working with a worn, short flat brush, I placed the most important directional lines and outlines, and started to consider the balance of warm and cool colours (stage 2). I wanted to check that the extremes of colour would work successfully within the overall design, and as you can see, I also indicated the principal light areas of the composition.

Next (stage 3), I quickly established a sense of the whole painting, blocking in the mass of the trees, the localized colour of the towpath, a suggestion of the sky, and some of the heightened colour on the barge and in the foreground reflections. Also at this stage I made further adjustments to the tonal balance. For

this painting I used a more intense colour palette than usual, consisting of cadmium red, permanent rose, French ultramarine, cerulean blue, burnt sienna, raw sienna, buff titanium and titanium white.

With all the basic painting in place and the drawing and a photograph as further reference, I was able to take a break and return to the studio. During the afternoon I set to work again, now aiming to firm up various shapes, such as the buildings and the narrowboat itself, and consider how far to develop the reflections, bridge, towpath and so on (stage 4). Essentially, I worked from the distance to the foreground. Thus I could gain a clear idea about the colour values in the background before relating this to the main shape of the boat, which I knew had to be quite punchy in colour.

The final work (stage 5) chiefly involved making the reflections and water surface more convincing, plus a few adjustments to the darker tones in the distance to enhance the sense of space and separation. I am sure it was an advantage to be able to work through from start to finish on the same day, because it minimized the disruption of transferring from *plein air* to studio painting. Although the final session was in the studio, the scene itself – and what it felt like to be there – were still very clear in my mind.

Stage 5: Fine Autumn Day, Clayworth Wharf, Nottinghamshire
Oil on canvas 40.5 x 40.5 cm (16 x 16 in)
Finally I checked the spatial and tonal relationships and made a few adjustments to the water surface and reflections.

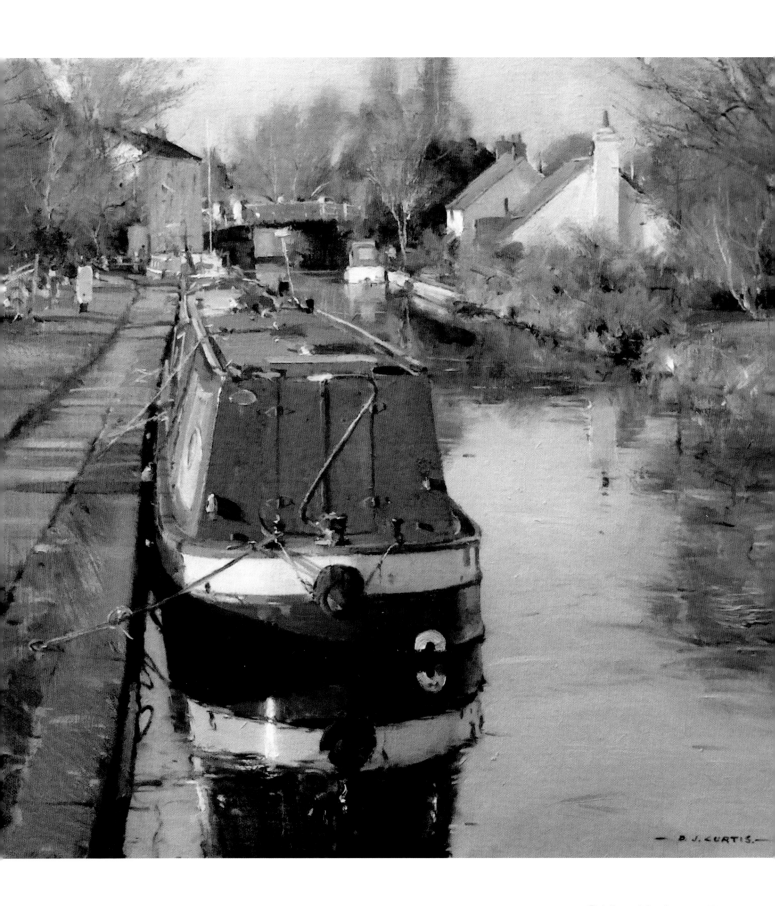

6 The considered approach

As well as the subjects painted on location, and those for which I use the 'halfway house' approach – starting *plein air* and finishing inside – there are some oil paintings that I produce entirely in the studio. These mostly include commissions, large-scale works, and ideas that require a more considered, resolved method of working.

Successful studio paintings rely on a number of factors, arguably the most important of which are the need for good reference material and the ability to keep the paint-handling as fresh and spontaneous as possible. As I have previously emphasized, something to be aware of with this type of painting is that, because there are no time constraints, results can easily become fussy and overworked, and so lose their vitality and impact.

When painting with greater deliberation and detail in the relative comfort of the studio, it can be more difficult to judge when a subject is finished. Moreover, if space is limited, there is not the same freedom and enticement one has outdoors to stand back periodically and evaluate progress. Outside, there is always a greater sense of urgency, and factors such as the light and the weather, as well as your own instinct, help suggest when it is a good time to stop. Nevertheless, the fact that the studio gives you more time, controlled conditions and continuity can prove a big advantage. Also, there is the opportunity to be much more ambitious with ideas. So providing you work with a due awareness of the possible pitfalls and keep in mind the value of painterly qualities, studio work can offer immense potential and rewards.

Morning Coffee, Montmartre
Oil on canvas, 51 x 51 cm (20 x 20 in)

The Studio Environment

The ideal studio is large and has plenty of natural light – preferably from the north, if you live in the northern hemisphere, to avoid glare from direct sunlight. However, most artists, particularly in the early stages of their career, have to make do with far less than the ideal studio space, although this need not be a problem. To begin with, as I found when I first started painting, any dedicated workspace is welcome. In fact, my first studio was a corner of a bed-sit, and it consisted simply of a table, a chair, a drawing board, an easel and the minimum of storage space.

Whatever type of studio you have, you can soon make it an inviting, inspirational place in which to work by pinning up reference photographs and drawings, building some shelves for art books and other useful items, improving the lighting, and so on. Try to use the space as effectively as possible: think about how you should arrange the studio furniture, and how to maximize the natural lighting and any other features of the room. The degree of comfort is a matter for you to decide, again in relation to the way that you like to work. Some artists choose not to have any home comforts in the studio, so as not to be distracted!

I have had several studios over the years and interestingly, whenever I have moved to a new one, people have warned me that I may not like it or be able to paint there. But I have never had any difficulty in settling into a new studio and making it my own. My present studio is a converted barn in my garden. The building has an interesting history – it was originally a slaughterhouse, and more recently the place where the village carpenter made coffins. Most of the ancient timbers have survived, and this gives the building immense integrity and character.

My studio space is large enough to be divided up into a number of distinct areas. These include separate spaces for oil and watercolour painting, a computer area, and a corner in which I have my office. Normally there are four or five paintings in different stages of development on the various easels and the large adjustable drawing board, and during a typical day in the studio I will do some work in oils and some in watercolours. Much of the studio is lit by a large, north-facing window, which gives fabulous natural light. I can also make use of several forms of artificial lighting, enabling me to create whatever quality of light I require for each painting.

Planning and Composing

In the studio, with the knowledge that you have various drawings and photographs to refer to, it can be tempting to start painting straight away, without doing any further planning or considering composition alternatives. However, the first idea is not always the best, so I would advise against being satisfied too soon. I usually start by making a sequence of thumbnail sketches. These help me finalize the composition and check that the principal shapes will work in the way I anticipated when I originally sketched and photographed the subject on location.

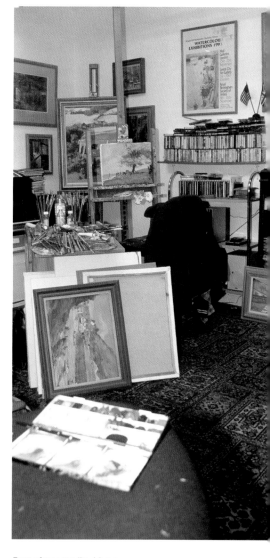

Part of my studio. I have never had any difficulty in settling into a new studio and making it my own.

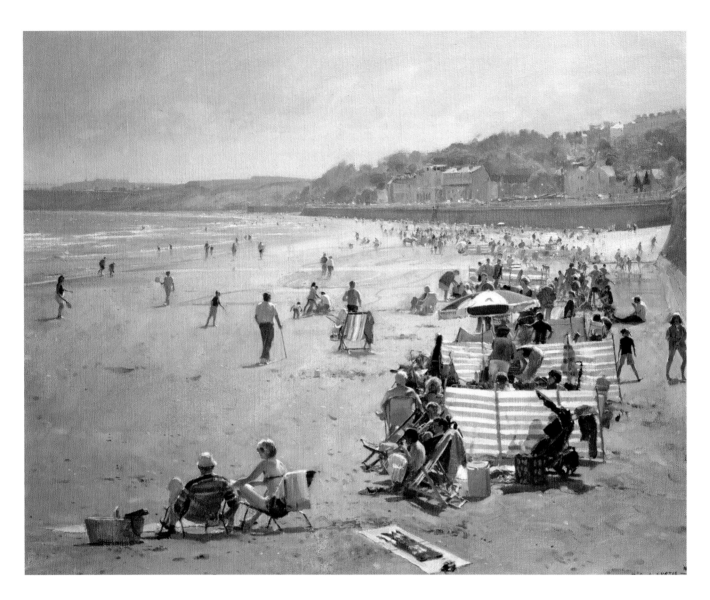

For a large-scale, complex studio painting some planning is essential, because much more is at stake in terms of the time and energy invested in the work. Painting technique alone is not enough to ensure success. Irrespective of the skills shown in applying paint and expressing ideas, if the important basic elements such as composition and colour harmonies are ill-conceived, the painting will fail to create interest and impact. At the other extreme, when an idea is planned in every detail, there is nothing left to discover and develop in the final painting, and so again the result will be disappointing and ineffective. The extent of your planning should aim somewhere between these extremes. And if ever you have any doubts about the value of planning, just remind yourself of the old saying: 'Fail to prepare; prepare to fail'!

Filey Coastline, Yorkshire
Oil on canvas, 61 x 76 cm (24 x 30 in)
There is something special about an almost deserted beach scene, but equally I find it interesting to paint the busy times when lots of people are having fun and enjoying their holidays.

The Painting Process

As with my *plein-air* paintings, one of the most important qualities that I strive for in my studio work is to create a convincing sense of mood and place. To achieve this quality I think it is essential to work from memory as well as referring to the appropriate sketches. This allows me to involve the feelings and responses that I experienced when I was at the location, gathering the reference material in the first place.

When you have had some experience of working on site it is easier to convey the same kind of energy and impact in your studio paintings. Conversely, if you have never worked on the spot, then it becomes extremely difficult to paint with a similar degree of spontaneity and interpretation. A dependence on photographs, without any knowledge or understanding of what it is like to paint from real life, usually results in soulless, laboured work.

Consequently, although studio paintings inevitably rely on photographs and drawings as their starting point and principal form of reference, such resource material must be used as sensitively as possible. Success in developing a painting in this way therefore depends to a large extent on the nature and quality of this material. When you are on location, you have to ensure that your sketches include enough relevant information to sustain the painting that you will make from them.

After a while, most artists develop their own form of visual shorthand when sketching, which enables them to set down the essentials of a subject quickly, and to do this in such a way that it conveys far more information than is apparent at first glance. A related point is that as you gain experience, you find that you can manage with less in the way of reference material. Ironically, one of the least helpful forms of reference are digital photographs that show every leaf and detail. This is especially so if they were taken by someone else in your absence, because in that case you have no first-hand experience of the subject matter at all, and no sense of what it was like to be there.

Above left: *Welcome Shade at Art in Action*
Oil on board, 30.5 x 25.5 cm (12 x 10 in)
This is an example of the demonstration painting that I do each year at Art in Action, the annual art techniques fair. It is a good discipline: I set up my easel and paint whatever is in front of me.

Above right: *The Haybarn with Geese*
Oil on canvas, 35.5 x 35.5 cm (14 x 14 in)
I thought this was an immensely interesting composition, with the character and poise of the geese set against some lovely interlocking light and dark shapes.

Right: *Vintage Car Workshop*
Oil on canvas, 61 x 51 cm (24 x 20 in)
When I went to collect a tyre for my vintage car I saw this wonderful workshop interior, which I could not resist – so I went straight back home to collect my paints!

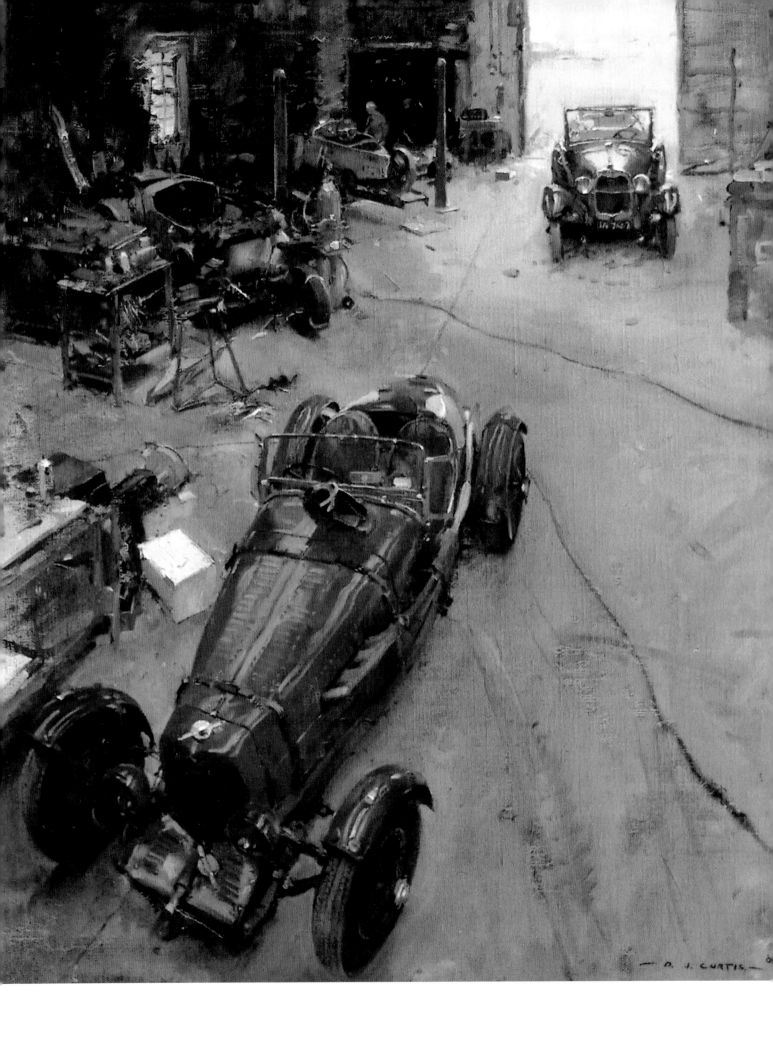

 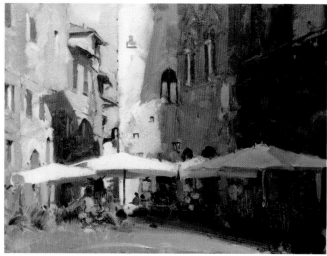

Drawing and Underpainting

Another way of keeping a studio painting loose and expressive is to restrict any preliminary drawing made on the canvas or board to the minimum number of marks. A detailed drawing is likely to encourage a fussy, tight approach in the subsequent painting. I think a painting should emerge from the vigour of the initial brushstrokes, and I want the first stage to suggest that a fantastic potential image is in store. The process of making every painting should begin with that excitement and sense of mystery and adventure.

These points are demonstrated in *Café Corner, San Gimignano, Tuscany* (shown here), a studio painting made on a fairly rough-textured white board. Here, the reference materials were some photographs and a series of thumbnail drawings in my sketchbook, which I used to help me consider various aspects of the composition. In oils, I always start directly with paint, in preference to charcoal. For *Café Corner, San Gimignano – Tuscany*, after very loosely and quickly scrubbing in the basic tonal arrangement I placed a few key lines and shapes, such as the grouping of buildings left and right, which in fact divide the composition roughly on the Golden Section (stage 1). You can see that I have also suggested a few areas of local colour – the pitch of the sky, the blue in the shadow area and the underplay of light on the umbrellas.

Relative to those areas I was able to place increasing amounts of local colour as well as various strategic and repeated colours, such as the blocks of yellow in the lower half of the painting (stage 2). Additionally, my aim at this stage was to set the scene more decisively by adding greater definition throughout, and I also considered more thoroughly the relative tonal and colour values, including that of the foreground. In the main I was faithful to the form, perspective and detail of the architecture, and I also added two figures.

The positioning of those first figures in the centre gave me an indication of the scale and technique I could use for the rest of the figures (stage 3). I wanted this figure group to add interest and life to the subject, and it was important that it was painted with the same verve and style as the rest of the work. As reference, I had some photographs, but I also relied on my knowledge of poise and body language – from many years of 'people watching' – to make the figures as lively and convincing as possible. This was particularly true of one or two strategically placed figures, such as the waiter and the man with the rucksack. The red chairs provided a very useful linking device in the colour scheme, and you will also notice that I did a little more work on the sky area.

Above left: *Café Corner, San Gimignano, Tuscany (stage 1)*
After blocking in the basic tonal values I placed a few key lines and shapes to get a sense of the overall design.

Above right: *Café Corner, San Gimignano, Tuscany (stage 2)*
Here, I began to assess more thoroughly the relative tonal and colour values as well as various strategic and repeated colours.

Café Corner, San Gimignano, Tuscany (stage 5)
Oil on board, 30.5 x 40.5 cm (12 x 16 in)
Lastly I added one or two more figures, and slightly enhanced some of the highlights.

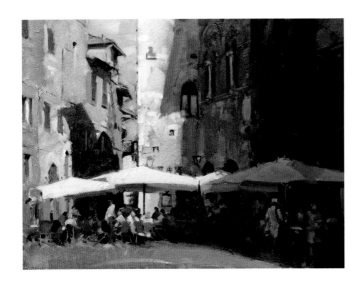 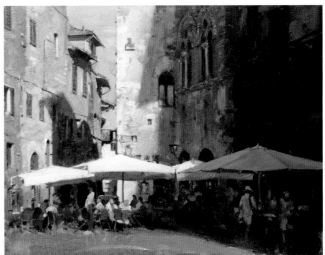

Next, I turned my attention to the buildings behind, firming up the structure a little and defining the windows, shutters and other features with slightly greater clarity (stage 4). Finally I added some more figures to help balance the grouping (the ones in blue at the back), and made a very small adjustment to the waiter (stage 5). I used my thumb to soften the edges of the shadow on the white wall, and slightly enhanced the reflected light in some of the windows. As in all my paintings, the finishing touches in *Café Corner, San Gimignano, Tuscany* were fairly discreet and restrained. Although these final accents and details are important, I know that the real success of a painting depends chiefly on the work produced in the initial stages.

Above left: *Café Corner, San Gimignano, Tuscany (stage 3)*
Now I focused on the grouping of the figures and the linking device of the red chairs.

Above right: *Café Corner, San Gimignano, Tuscany (stage 4)*
Returning to the buildings, I added a little more definition where necessary.

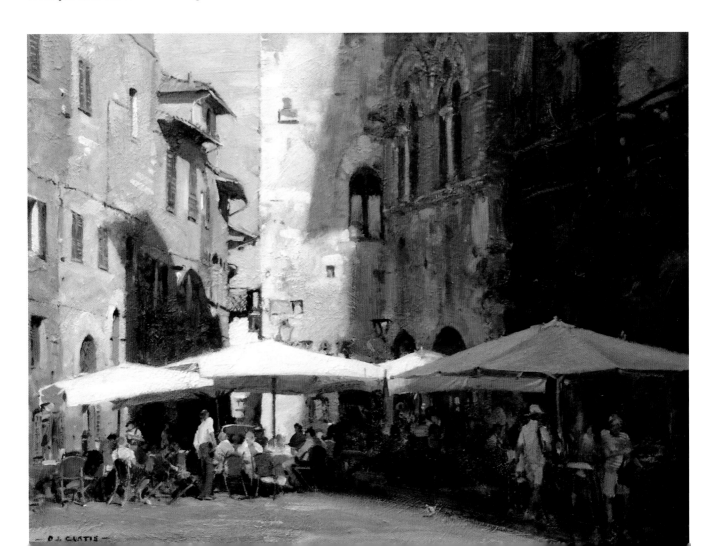

Varnishing and Framing

There are two things to consider with a finished oil painting: whether to varnish it, and how to frame it. I generally leave a painting for at least three weeks before varnishing, and even then I only use a thin coat of retouching varnish, just to freshen up the darks. Because I seldom use linseed oil in my paint mixes, the paintings are dry enough to be varnished soon after completion. The advantage of retouching varnish is that it does not seal the paint surface, but allows it to expand and contract.

I choose the frames in collaboration with my framer, who has helped me for the past twenty years or so. My ideal frame is one that is in sympathy with the painting, isolates it from its surroundings, but does not shout 'I'm a frame'! For most pictures I prefer quite wide, unfussy mouldings with a slight texture, perhaps in a dusky green or blue/purple wash and with a narrow gold leaf or ivory slip.

For me, painting is a necessity, and above all I love to be outside working directly from the subject matter and confronting the various challenges that such work inevitably entails. In this book, by explaining in detail my approach to oil painting, both *plein air* and in the studio, I hope I have encouraged you to consider the immense potential of this medium or, if you are already an enthusiast, to develop your work further. Oil paint is the medium I feel most at ease with, principally because of its particular handling characteristics and forgiving nature. Everything about painting in oils is exciting and rewarding, and certainly during my long career as a professional artist I have found it the most reliable medium for conveying the transitory effect of light and mood.

Above: *Sharp Morning Light, Sandsend*
Oil on canvas, 61 x 76 cm (24 x 30 cm)
The subject here is essentially the particular effect of light on shallow water.

Right: *Morning Sun and Smoke Haze, Staithes*
Oil on canvas, 30.5 x 40.5 cm (12 x 16 in)
For me, this is the ultimate subject. Wonderfully atmospheric, it was painted with total commitment and excitement.

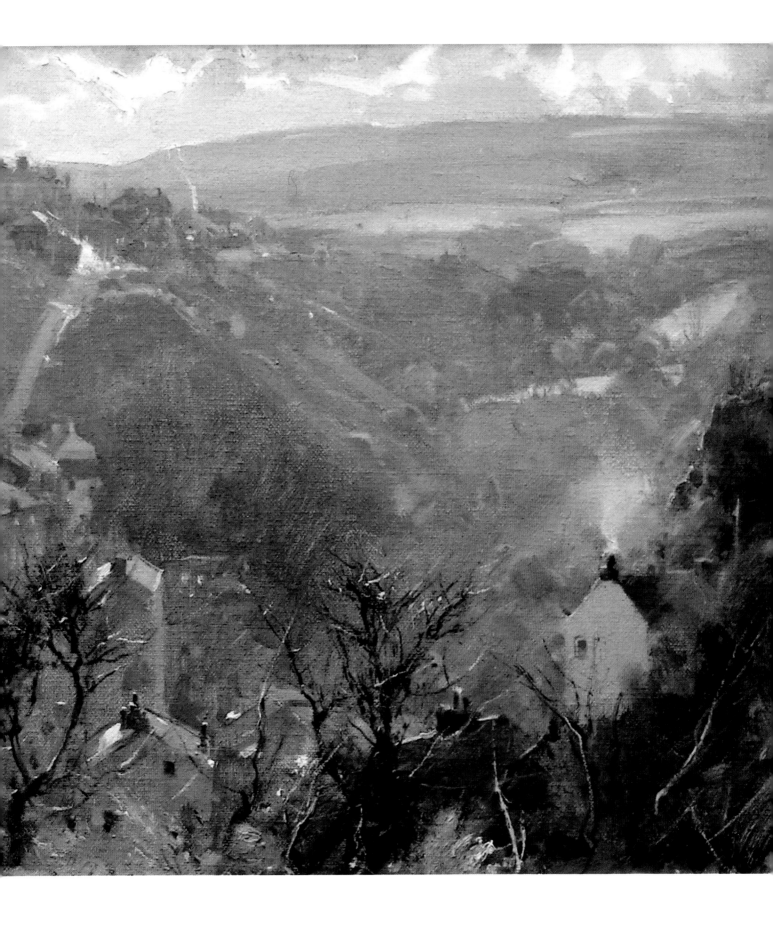

Index